PAINTING
Capturing the
DYNAMIC
Spontaneity of Nature
WATERCOLORS

Domenic DiStefano, AWS

Art Instruction Associates, Sarasota, Florida

Distributed by North Light Books, Cincinnati, Ohio

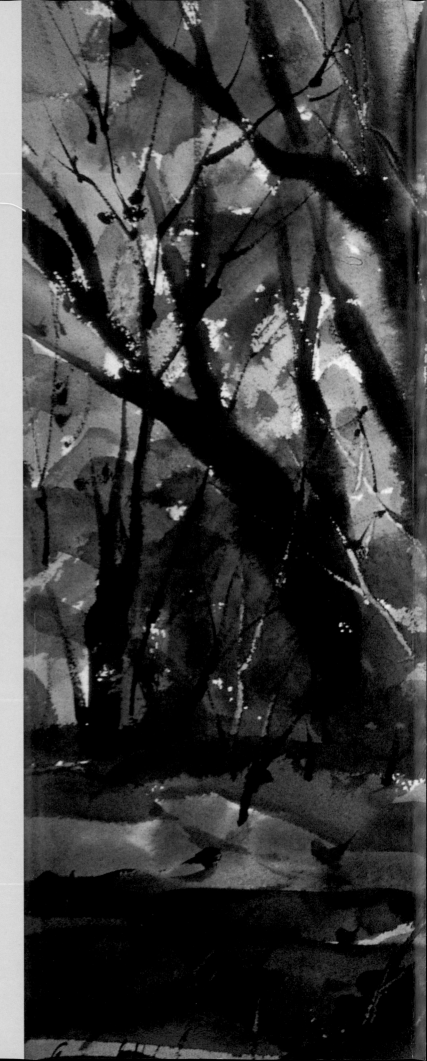

PAINTING DYNAMIC WATERCOLORS
Capturing the Spontaneity of Nature
by Domenic DiStefano, AWS
© Copyright 1999 by Art Instruction Associates
Sarasota, Florida 34233 USA

Published by Art Instruction Associates
5361 Kelly Drive, Sarasota, Florida 34233
TEL: 941-379-5827, FAX: 941-379-7735

ISBN 0-929552-15-6

03 02 01 00 99 5 4 3 2 1

Distributed to the book trade and art trade in the U.S. by
North Light Books, an imprint of F&W Publications
1507 Dana Avenue, Cincinnati, Ohio 45207
TEL: 513-531-2222, 800-289-0963

Edited by Herb Rogoff

Art Direction by Stephen Bridges

Design by Laura Herrmann

Indexing by Ann Fleury

Project coordinated by Design Books International
5562 Golf Pointe Drive, Sarasota, FL 34243

Printed in Hong Kong

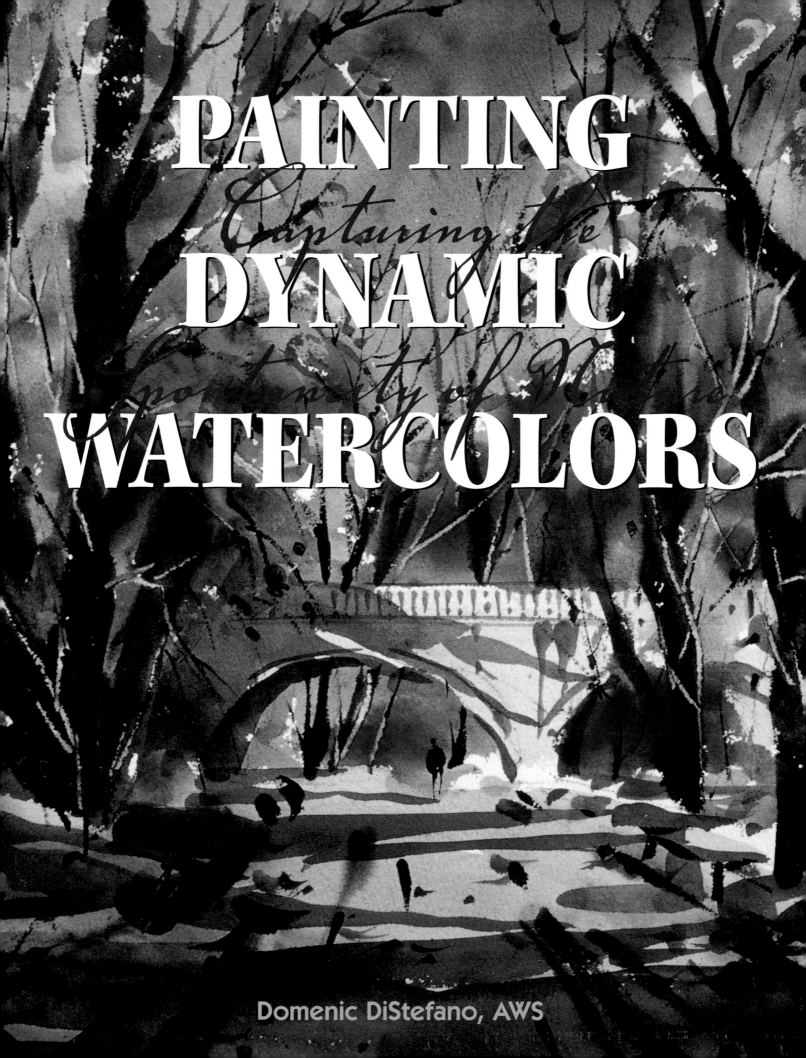

PAINTING
Capturing the
DYNAMIC
Spontaneity of Nature
WATERCOLORS

Domenic DiStefano, AWS

red dorys
22 x 30"

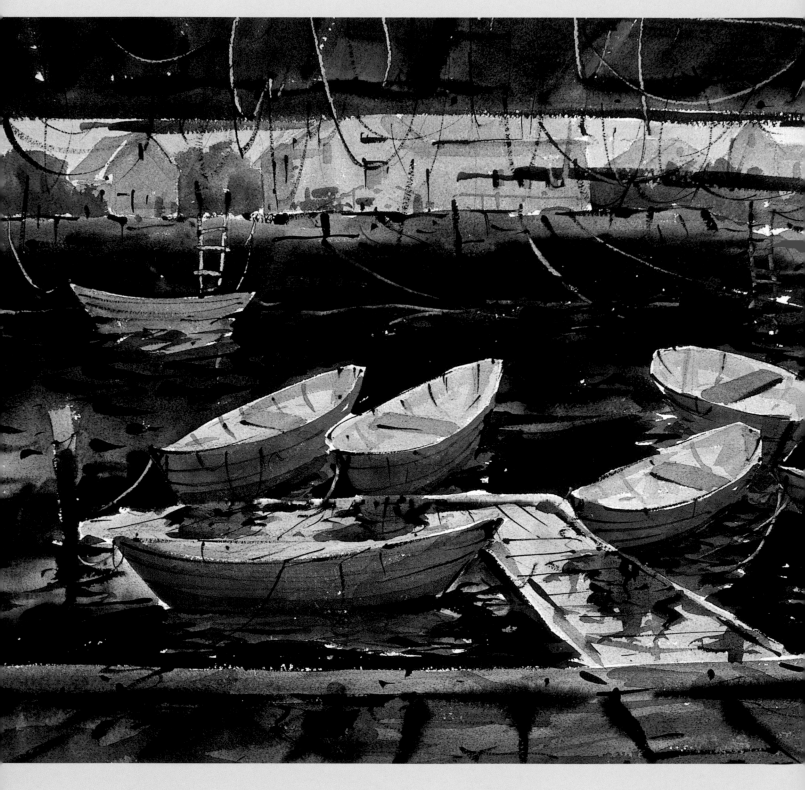

Table of
contents

introduction

...I always go out with the positive idea of coming back with a finished painting.

THIS BOOK IS ABOUT WATERCOLOR PAINTING AND MY CONCEPT OF THE medium. As you read through it, you will be made aware of what watercolor means to me. I can say, at this early point in the book, that for me watercolor is bold, direct, spontaneous and as simple a statement as I can make. The word "juicy" is the operative word for me because it means using strictly transparent colors without the use of opaque paints or any other media. I am a purist, and have been throughout my long career at the easel. I paint according to the rules, for there are definite do's and don'ts that must be adhered to. The late Edgar Whitney, the famous watercolorist and teacher, compared the discipline of painting to a court of law. He was right. Watercolor painting has a history of precedence which, I believe, every practitioner must follow.

You will also learn about the importance of watercolor papers, those that I like to use, and the selection of colors that, after long years of trial and error, I've chosen as my palette. Then, of course, my brushes—the types that could more easily help me to make my colorful voyages successful ones.

I am primarily an outdoors painter, on painting location during all four seasons of the year. I am from the Philadelphia suburbs and can state emphatically that we *do* get four definite seasons. During all four seasons, when weather permits and, many times, when I have painted between raindrops and snowflakes, I can be found, challenged by the vistas before me. I feel at home painting in the fields, by

the sea and even in city streets where more than once I have been chased by lawmen anxious to keep their vehicular traffic moving smoothly.

The sounds that go with painting on location appeal to me. The rustle of the leaves in autumn as they begin to lose their tenacious hold to their branches; the no-sound of gently falling snow in the country; the sounds of summer at the shore, the ocean's light wavelets rolling over the stones and seashells; the gusts of spring, especially early in the season when winter is starting to let go.

I like to get an early start each morning, giving me a chance to look around for an ideal spot for that day's painting. As I get my equipment ready, my eyes are already searching for composition, design and color value, putting me in a better position to make some final changes when I start my actual drawing. I make very few pencil lines. I do a lot of drawing with my brush, preferring not to confine myself to a given line. In this way, I can feel free to expand my lines in any given direction, as the painting progresses, to help my composition and design.

Finally, I always go out with the positive idea of coming back with a finished painting. That should be every landscape painter's goal.

I hope that after reading this book, you will not only enjoy a successful outing with your paints and brushes, but that it will far surpass any attempts you had previously made.

Domenic DiStefano
Upper Darby, PA

An interested bevy of students look on while
I demonstrate the art of landscape painting at
a workshop at Hodgkin's Cove, Gloucester, MA.

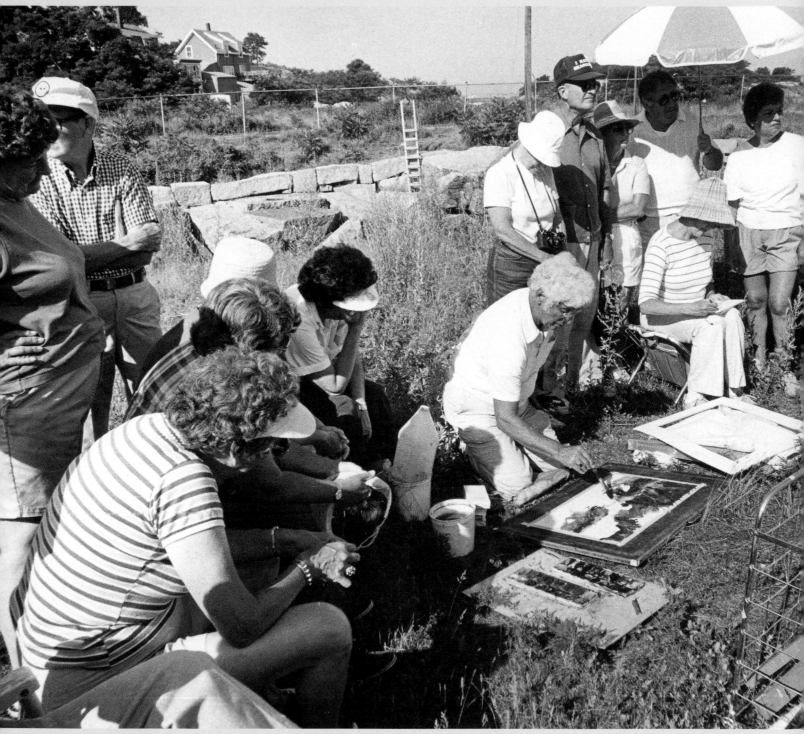

Photo: Domenic Loschiavo

CHAPTER ONE

1

painting
Materials &
setup

*I*T IS INTERESTING TO NOTE THAT AN ARTIST'S EASEL, QUITE familiar to all who paint, derived from *ezel,* the Dutch word for donkey. We can only speculate that an early Dutch (or Flemish) artist must have compared the important piece of furniture in his studio, the sole support for his painting, to the beast of burden in his stable, well known as an animal of great strength. Painting on location, as many of you may have already discovered, is no job for a weak back.

my gear for outdoor painting

I carry all of my painting material in an over-the-shoulder bag, much like a backpack. For my water, I have found that a plastic gasoline container (a brand new one) fills the bill perfectly. It has a flat bottom and, consequently, won't roll over in my car and spill. Extra water is vital. Since I never know how available water may be on each painting trip, I always make sure to have an extra supply along for rinsing brushes during painting, for mixing with my paints for washes, and for cleanup at the end of the session. A plastic pail the size of a sand bucket serves me well as my painting reservoir. The more water you have, the cleaner your brushes will be. The large capacity that the bucket affords you makes it possible to slosh your brushes vigorously to get out all the color, thus preparing them for new color mixtures. The cleaner your brushes are the cleaner your painting will be since all of the paint sediment will sink to the bottom of the water container.

I am shown here in a painting pose that is typical of the way I work. Many onlookers think this unorthodox way of painting is unique, others think it's "screw-ball." The consensus, however: **"You can't argue with success."**

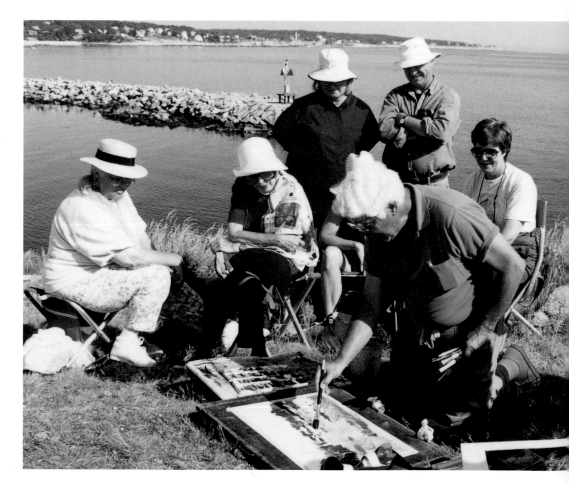

my unusual "easel"

Another item for me to carry is a wooden board with my sheet of paper taped to it.

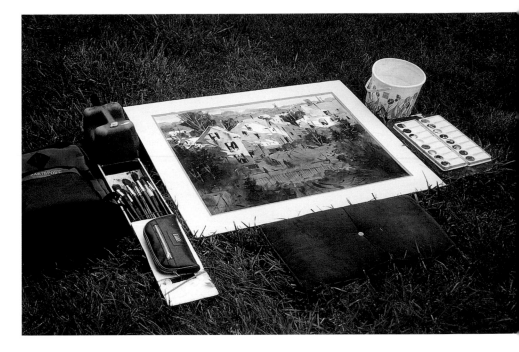

All of my materials are set in position for my painting session.

The board, affixed with a convenient handle, serves as my "easel." I do not use an easel in the conventional sense. Instead, I rest my board on the ground, get down on all fours, and paint in this manner. This way of painting surely is unusual, different, and even, according to some onlookers, screwball. I kneel on the ground using a pad to save wear and tear on my knees. I call this my "prayer rug," not meaning any disrespect, but because I constantly pray for a good composition and painting. I have been working this way for as long as I can remember and will continue to do so as long as I can physically handle this unorthodox way of painting. Right now, I am comfortable and at ease painting this way; I like it because I get a different view and perspective of my subject matter. You can get some unusual compositions at this level. Painting in this position is not for everyone but it works for me. My painting materials are within easy reach, which is really important, because not finding what you want during the hurly-burly of painting outdoors can be unnerving.

I also carry what I call "work mats" both for full sheets and half sheets. The work mat acts as a frame when I am doing my sketching. It helps to define my composition.

I also use it to check my painting in progress; it helps me to see how I'm doing. For the final steps of my painting, the work mat remains atop the painting.

paper

I decided upon the watercolor paper that I now use exclusively after many years of experimenting with most of the important brands. I settled on Arches, a French-made paper that has been around since 1492. I only use the rough texture of Arches, and work with only two weights: 300 lb. for a full-sheet painting; 140 lb. for a half-sheet. The paintings that appear in this book were all done on full sheets (22 x 30") of Arches rough texture.

As for which paper you should use, I suggest that you do some research for yourself. Run each sheet that you try through the paces: check the paper that I now use for its absorbency (how much, how little); the ease at which you can scrape out or wipe out mistakes; the clarity of the white as it shines through the colors. Relate it with others on the market. You will also want to compare the relative costs of each paper you try. You may find that you'll prefer another brand of paper. There are some relatively inexpensive papers on the market, which can help you do a serviceable job. The only way to find out which paper is for you, as I've just written, is to experiment with a few of them.

brushes

Brushes are the most expensive materials that are necessary to have in your studio. I use only two types: red sable and sabeline; two shapes: round (pointed) and filbert (a flat brush that is rounded at the tip); and only large sizes. I do not use any chisel-edged brushes. As for specific sizes, I'm sorry I can't help you there. The imprinted numbers on my old brushes have worn down a long time ago. When I have to buy new brushes, I don't buy by actual size; I've found that each brush's size varies from maker to maker. I merely rely on how the brush appears to me at the art dealer's shop. If the size looks familiar, and the feel is about right for my hand, I make the purchase. All I can say is that I use sizes from small to large in each style.

Red Sable. The best hair that is used for red sable brushes comes from the tail of the red marten. It is also called the kolinsky because its habitat is the Kola Peninsula in Siberia. Red sable brushes are extremely hardy, making the spring of the hair quite remarkable. Red sable hair is unique in that each individual hair has three components: a tip, a belly and a root (unlike a human hair that has one thickness throughout). When lots of tips are put together, they form a

MY STYLE OF BRUSHES

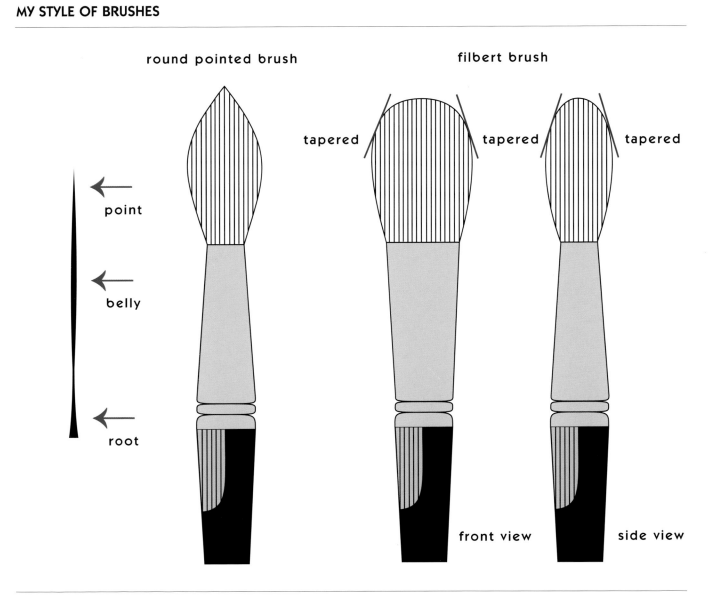

round pointed brush

filbert brush

point

belly

root

tapered

tapered

tapered

front view

side view

The drawing at left shows one red sable hair (greatly magnified, of course). You can see its unique characteristic: a hair of three thicknesses. At its immediate right, a highly stylized drawing of a red sable watercolor brush showing what happens when many points and bellies are joined together to make a brush. You can't see any of the roots since they are located inside the ferrule.

The diagrams shown above are two views of a filbert-shaped brush. This shape can be made of all hairs: sable, bristle, sabeline, synthetic, etc. I prefer sabeline, which is oxhair that has been dyed to look like sable.

brush that has a very sharp point. And when lots of bellies are put together, the reservoir that is formed is capable of holding a large quantity of color. I only use large sizes which, as you can imagine, is pretty costly. Its price, then, is a minus factor of red sable, especially for beginning painters. At least the watercolorist can take comfort in one aspect of using this expensive brush: watercolor paints, unlike acrylics and oils, do not wreak havoc with brushes, which means that red sable lasts a very long time, making it possible for you to pass on to your heirs all of your valuable red sables.

MY PAINTING SET-UP

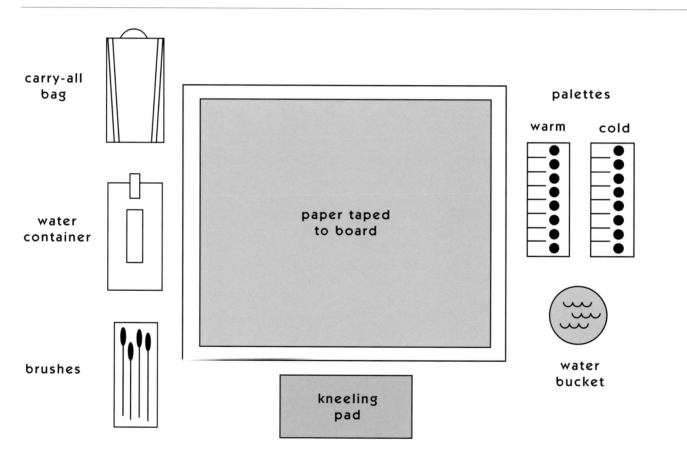

I prepared this sketch to identify for you the materials that are shown in the photograph on page 11. They are placed in such a way that equipment is always at hand. Why spend valuable outdoor painting time, when the light can change radically, to search through a paintbox or brushbag? I would like to point out the important items that are shown in this sketch: my paper that's taped to the wooden board (you can also use the new foam boards for lighter transport); my kneeling pad "prayer rug" which can be any kind of pillow; a brush holder; a plastic bucket for water and a container for extra water.

Sabeline. Hair that comes from the ears of oxen and then dyed to look like red sable is called sabeline. It makes a strong brush, able to withstand the rigors of the rough texture of the paper. It has a spring somewhat similar to red sable. Sabeline is a fine brush to work with, and its price is kinder to your pocketbook. My sabeline brushes are all of the filbert shape which is a compromise between the flat and the round. A filbert is basically a flat brush that is rounded at the tip. Here, too, I use only large sizes, in this case 3/4 inch and one inch.

my materials check list

paper Arches 300 lb. and 140 lb. Be sure to take two to four extra sheets.

paint Winsor & Newton Watercolors (my palette of colors is listed and explained in Chapter 3). I have extra tubes of most used colors.

brushes Large sizes red sable and sabeline.

palette Palettes are now made of plastic which work well. In the old days, metal palettes had a tendency to rust once the protective enamel chipped away. I use two palettes, one for warm colors, one for cold colors. I explain this in greater detail in Chapter 3.

pencils Do not use any pencils marked with "H"; their hard leads can dig into the surface and create impressions that will show up through the colors right into the finished painting. I use a thick lead that fits into a holder made by Koh-i-noor. The degree of softness is equivalent to 2B, stocked by all art material stores. The drawing you will make to prepare for the painting has to be done lightly and sparingly. After all, you are painting a painting not drawing a drawing.

water Bring extra water. Bring a large bucket, the size of a sand bucket. The more water you use, the cleaner it stays because all of the sediment goes to the bottom. Reminder: Your water container and bucket should be made of plastic. No glass!

knife I use a knife as a "brush" to create weeds, twigs, ropes and to achieve other effects.

Note: Be sure that you check all of your materials before going out to paint. There is no turning back once you are on location.

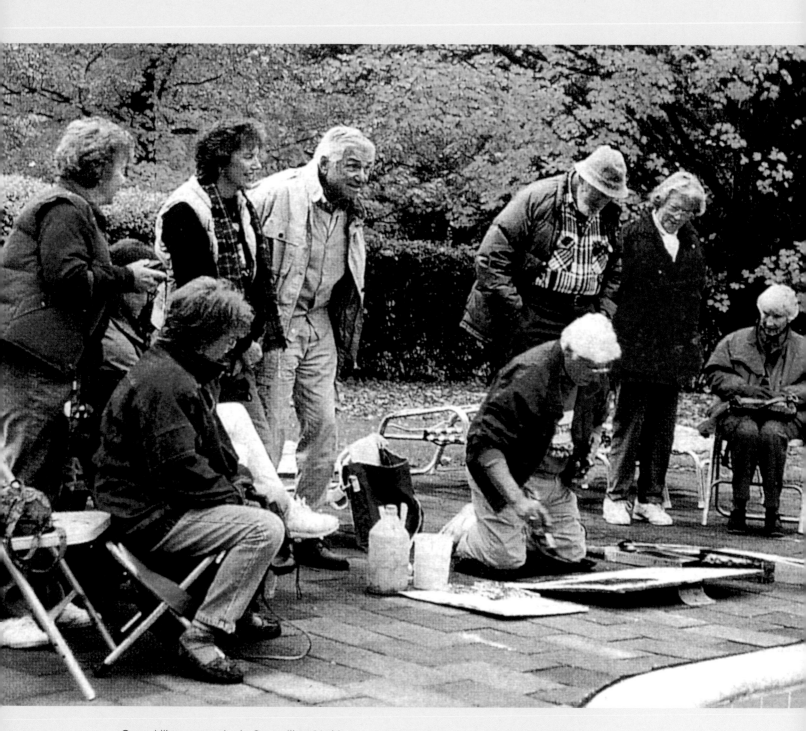

On a chilly summer day in Greenville, NY, this group gathers to watch me start a landscape.

After my "show-and-tell" demonstration is done, they will try the same scene.

2

my way of painting

THE PURPOSE OF THIS BOOK IS TO ILLUSTRATE WATERCOLOR painting in a direct and spontaneous way. What I want to share with you is how I paint directly on the spot and the joy of painting on location regardless of the weather.

When I find a location that interests me I start putting the composition together in my mind. While the general location intrigues me, I rarely find a scene that is perfectly tailor made for me, one that I can translate literally to my paper. In most cases, I have to edit what I see before me for best pictorial impact.

I'm not afraid to move things around. If there's a tree I don't like, I'll borrow one that suits me. If a house isn't where I want it, I'll move it. I do this editing mostly while I'm sketching the composition. Every once in a while, though, I will make a change during the course of the painting process if I feel it will enhance the composition.

Don't be afraid to move things. It takes practice, knowledge and courage. Your main objective, after all, is the finished painting.

Havertown is not far from my home in Upper Darby, a suburb of Philadelphia. I scouted the streets and found a scene that appealed to me. You can see from the photograph that I took after I had completed my painting, that I had to make changes. I'm sure you will agree that they were for the better. Please keep in mind that this scene was painted on location and not— *never*—from the photograph.

Before I go on with the progression of steps that I used for the painting of Darby Road, I'd like to simplify the painting procedure in the following way, which is just a general outline. (I hope you understand that a simple composition will take less steps; a more complicated one will require more.)

1. sketch my composition
2. dark values
3. middle values
4. shadows
5. sky
6. finish with calligraphy

STEP 1

I sketched my composition, using few pencil lines since I prefer to do a lot of drawing with my brush. Checking with the photograph, you can clearly pick out the ways I've altered the design: pulling the house out from behind the foliage; moving the telephone pole closer to the focal point—the house; relocating the tree to provide a dark background for the other house on the left.

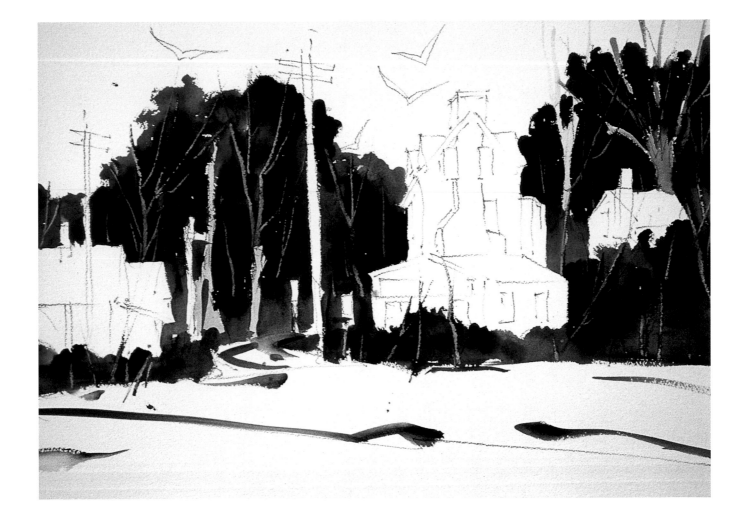

STEP 2

I left as much of the white of the paper as possible while I started with dark notes of Hooker's Green, Burnt Umber and Indigo Blue for the trees. I always start with the dark values; they set the theme of the composition. It's not easy to put down a dark value as my first statement on a blank sheet of paper, but it works for me.

Dark values come first with me; they set the whole theme of the composition.

STEP 3

The middle values came next, when shapes began to be defined. The rooftops were Burnt Sienna and Burnt Umber. The foreground was Raw Sienna and Burnt Sienna with a touch of Cerulean Blue to make a green. The warm notes made me more secure and comfortable with the initial dark greens of the previous step.

You don't want to overplay values; save some for later.

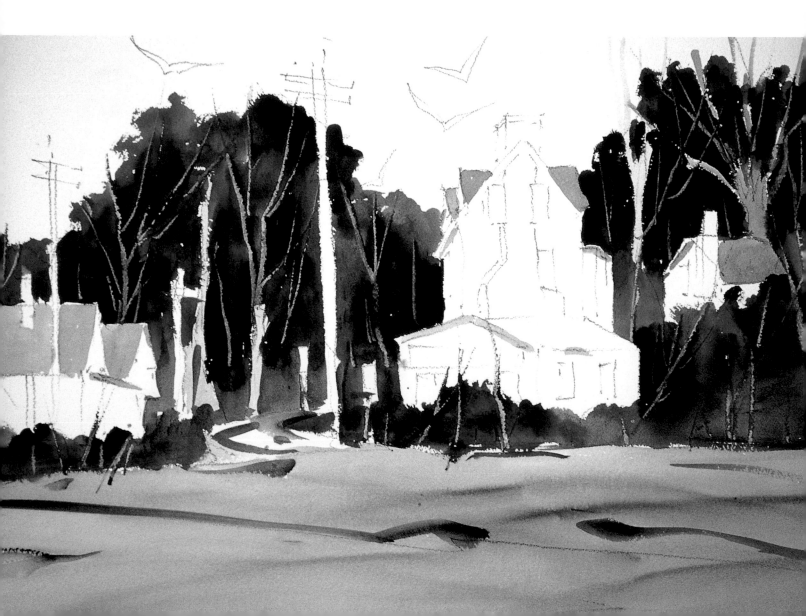

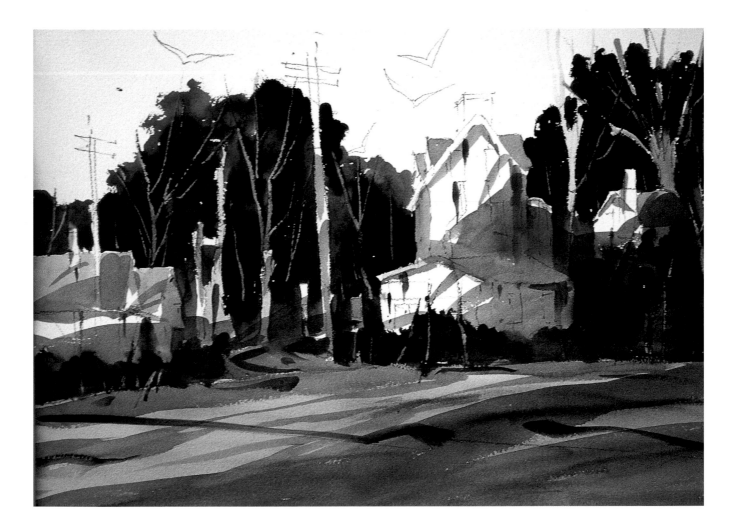

STEP 4 *With the whites as the white of my paper, I started to design my shapes with my shadows, which is a big part of pulling the composition together. Shadows should be a middle value. When I overlaid my shadows on the rest of the painting, I wanted the underpainting to come through. The shadows were on the warm side. I used Burnt Sienna, Burnt Umber and Cerulean Blue. The rust marks were made of Burnt Sienna.*

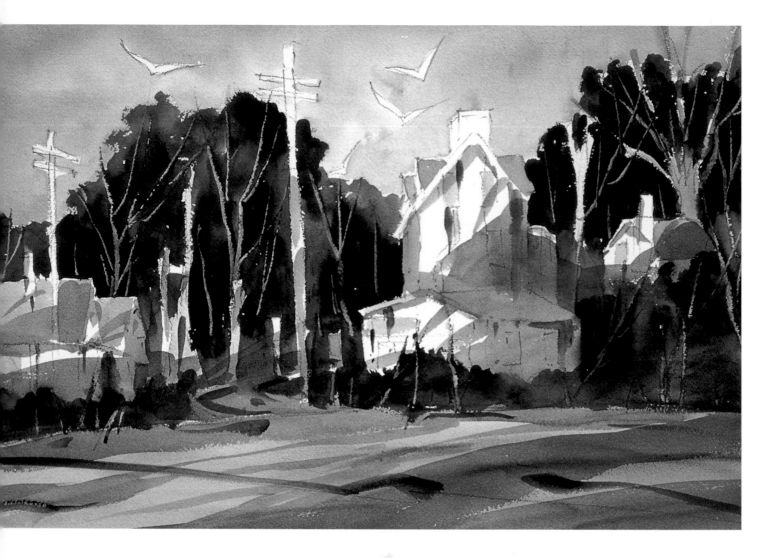

STEP 5

One thing that seems to surprise people who watch me demonstrate is that I always put my skies in last. The reason for this is that I don't want the sky to dictate the colors or values of my paintings. What I am looking for is the end result—"a good juicy watercolor." To help my shapes of color, I try to leave as much white paper as possible. Composition and design determine how much white paper to leave. In my opinion the loss of white paper cannot be restored by the use of white opaque. There is a certain beauty gained by leaving the paper white. The sky is a middle value on the warm lavender side. To get this color, I used Indanthrene Blue (which replaces Permanent Blue in the Winsor & Newton line of watercolors) and Alizarin Crimson for this to complement the rest of my painting. In order to make the birds white, I painted around them with the sky value.

There's a tendency to copy a photograph religiously...

I took this photograph of the scene after I painted it on location. I was interested in comparing the painting with the live version of Darby Road to see how much editing I had done.

It's far easier, at least for me, to make changes on the spot. There's a tendency to copy a photograph religiously as if the fear of being struck down by some strange force dictates the need to adhere to the material that was created on film. I see this over and over again in students' paintings. You can easily see that this was not the case in my painting of the scene.

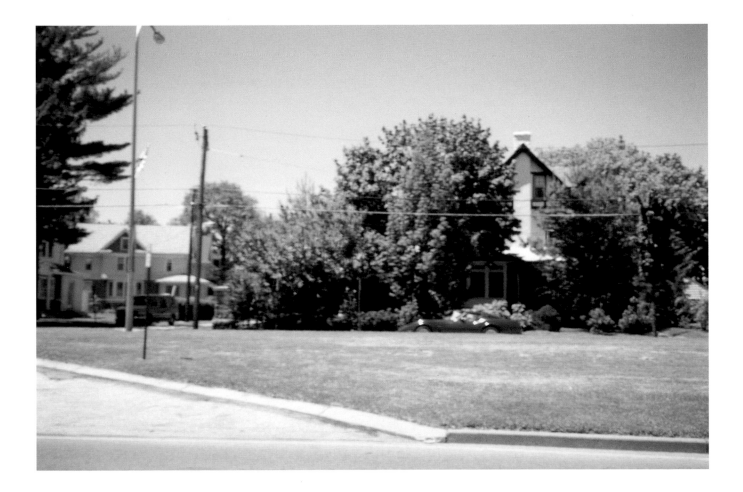

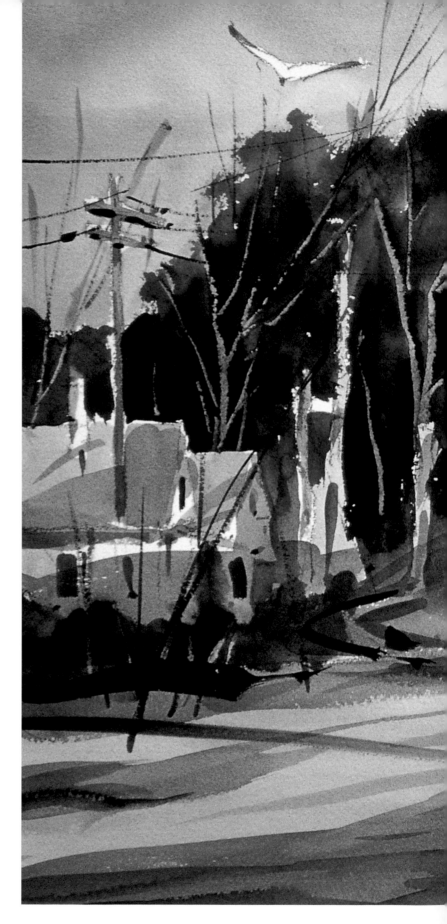

STEP 6

To finish the painting, I added dark notes of Indigo Blue and Alizarin Crimson. I wanted my dark notes to have a glow. In this painting, the dark notes are on the warm side because of the Alizarin Crimson in the mixtures.

darby road, havertown, pa
22 x 30"

The composition came alive with finishing touches of what I call the "coup de grace" or calligraphy. The only thing left to do was to sign my name.

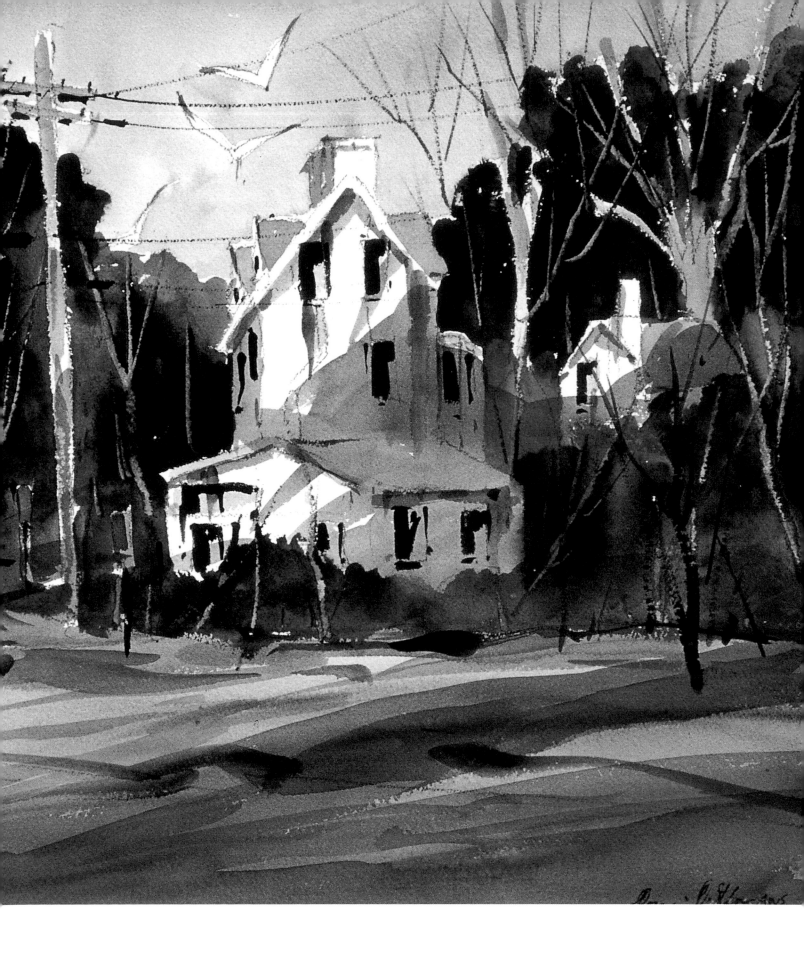

workshop at eastern point, gloucester, ma
Photo: Domenic Loschiavo

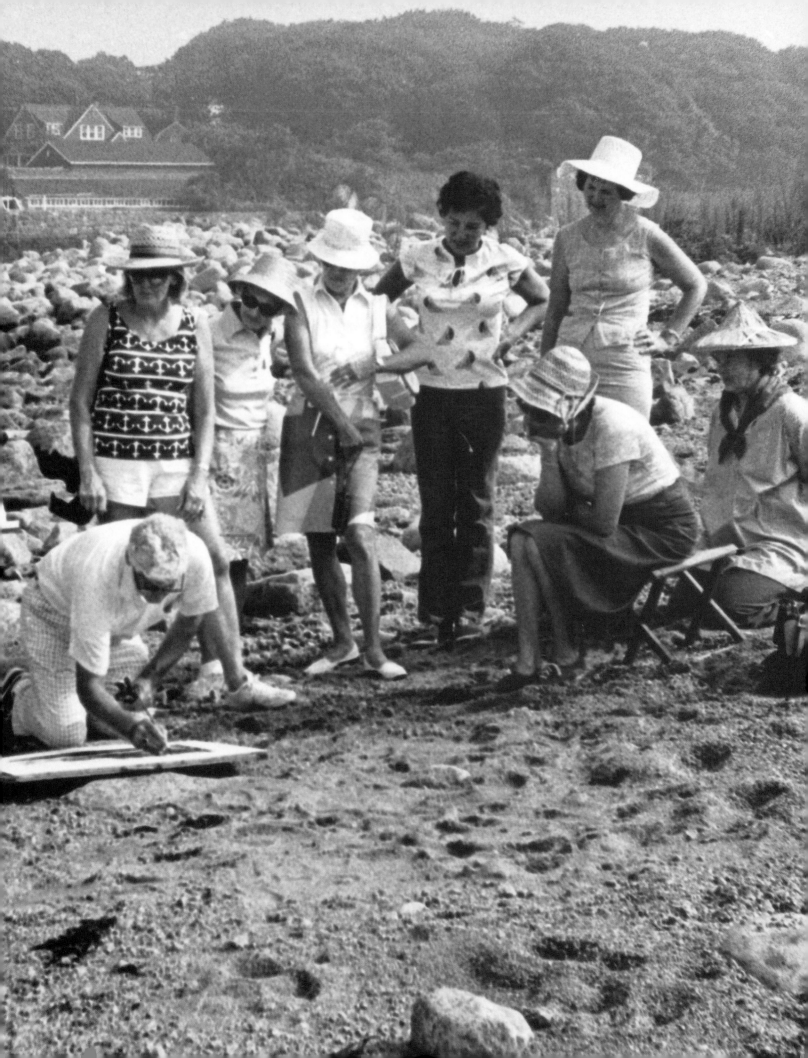

You can see in this photograph of a demonstration
at Lane's Cove, Gloucester, MA, how convenient
my materials are to me and my painting.

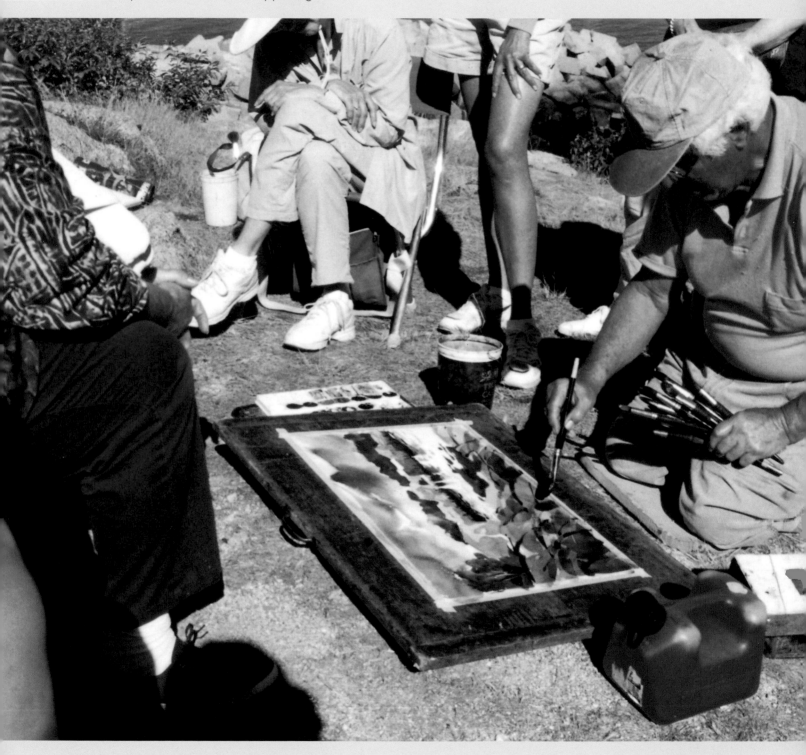

3

my color family

Y "COLOR FAMILY" HAS NINE MEMBERS: ONE RED—ALIZARIN Crimson (my primary red); four yellows—Yellow Ochre (my primary yellow), Raw Sienna, Burnt Sienna, Burnt Umber; three blues—Indanthrene Blue (my primary blue), Cerulean Blue, Indigo Blue; and one green— Hooker's Green.

It took me many years of adding and deleting colors to come up with these nine. How did I arrive at them? Well, I knew I had to have earthy colors to help me record the image of nature. Each color that I chose to use, therefore, would have to be one that was evident in nature. This meant that such bright colors as the Cadmium Yellows, Cadmium Reds, Cadmium Orange, and others, could not be part of my "natural" palette. Why? Simply look at the world around you, and ask

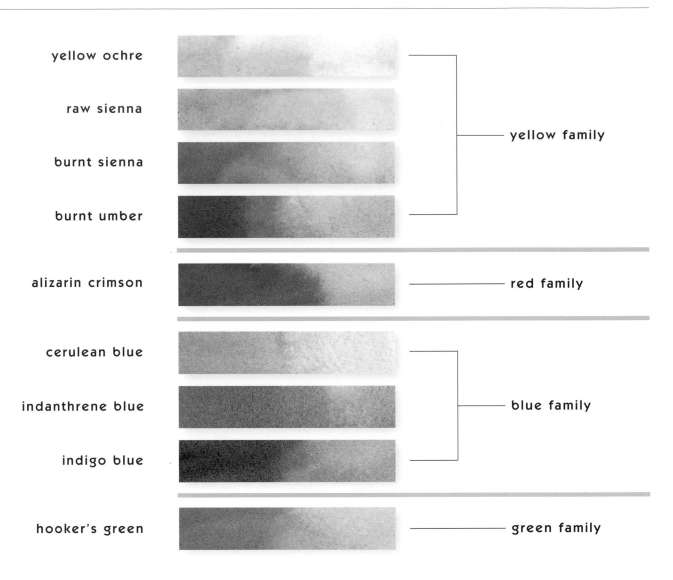

yellow ochre

raw sienna

burnt sienna

burnt umber

— yellow family

alizarin crimson

— red family

cerulean blue

indanthrene blue

indigo blue

— blue family

hooker's green

— green family

yourself: how many of these bright colors show up in nature? As a landscape painter, I asked myself that same question, and I came to the conclusion that it would be much wiser to paint with the more earthy (chromatically reduced) colors of my palette. With the palette that I have settled on, after much experimentation, I can paint anything that I see in the great outdoors during all four seasons. To prove this, take time out, right now, to flip through some of the illustrations in this book. You will see for yourself how successful these nine colors have been for me.

my brand of paint

The only brand of watercolor paints that I use is made by Winsor & Newton. I have been happy with their quality; their colors have worked well for me (I only paint with colors that are graded AA [extremely permanent] and A [permanent]). This preference for one line of colors does not mean that I haven't tried the products of other manufacturers. I have painted with several brands, and done so with the same curiosity and intensity that I employed to come up with a workable palette of Winsor & Newton colors. After giving all the other important brands a fair test, I settled on W&N's paints; it has been—and continues to be—a rewarding experience for me.

Recently (within the last two years or so), Winsor and Newton made some changes in their lineup of colors. The only modification that concerned me was their substitution of a color named Indanthrene Blue for Permanent Blue. It turned out to be not that big a deal because Indanthrene Blue works like a charm.

water, water, water

I suppose there are some of you who are accustomed to using brands of paint other than Winsor & Newton. You will find that all of my W&N colors are readily available in all other brands, except, of course, for Indanthrene Blue. The closest to it is Permanent Blue. Check with your dealer about the availability of Permanent Blue in various other brands of watercolor paints.

This may sound funny to you, this being a book about water-color, but I can't stress too strenuously how important water is in your painting. The truth is that many students don't use enough. Think of water as a medium to control the intensity of your colors. You do this by the amount that you use. All of my colors are transparent. I say this fully aware that Yellow Ochre and Cerulean Blue are known to be opaque. Any color, even the opaque cadmiums, can be made to be transparent if you use enough water. It will take a little practice to feel the balance of water and paint on your brush.

get to know your colors

The best advice I can give you about getting to know the characteristics of all your colors is to tint each one with water. First, paint out the color as it comes from the tube (the mass tone). Then, add water to the swatch of color, diluting it as you draw it away from the mass tone color. Making this chart will show you what happens to each color with a little dilution and then with greater amounts, making you more familiar with your palette. Oil painters use their white paint to tint their colors. Traditionally, though, white paint is not used in watercolor painting. As a rock-ribbed purist, as I had told you in the Introduction, I can say that I have never used white paint. Instead, I rely on the white of the paper to shine through the transparent colors in order to achieve an effect that's somewhat similar to that of the use of white paint in oil, acrylic and pastel painting.

light & heavy-bodied colors

The significance in knowing which colors of my palette are those I call "light-bodied" ones (thinner in consistency) and also "heavy-bodied" ones (thicker in consistency) is that this will give you a hint as to how much water to add. The light-bodied colors are Alizarin Crimson, Burnt Sienna, Burnt Umber, Raw Sienna and Indanthrene (or Permanent) Blue. They don't require as much water as the heavy-bodied colors, which are Yellow Ochre, Cerulean Blue, Indigo Blue and Hooker's Green.

Finally, these are colors that work for me. As I have written earlier, nine colors does it for me. I know some people who don't feel comfortable with fewer than twenty. If that's what will work for you—great! Set up a fresh sheet of paper, all of your colors, plenty of water and go to it. The proof is in the result.

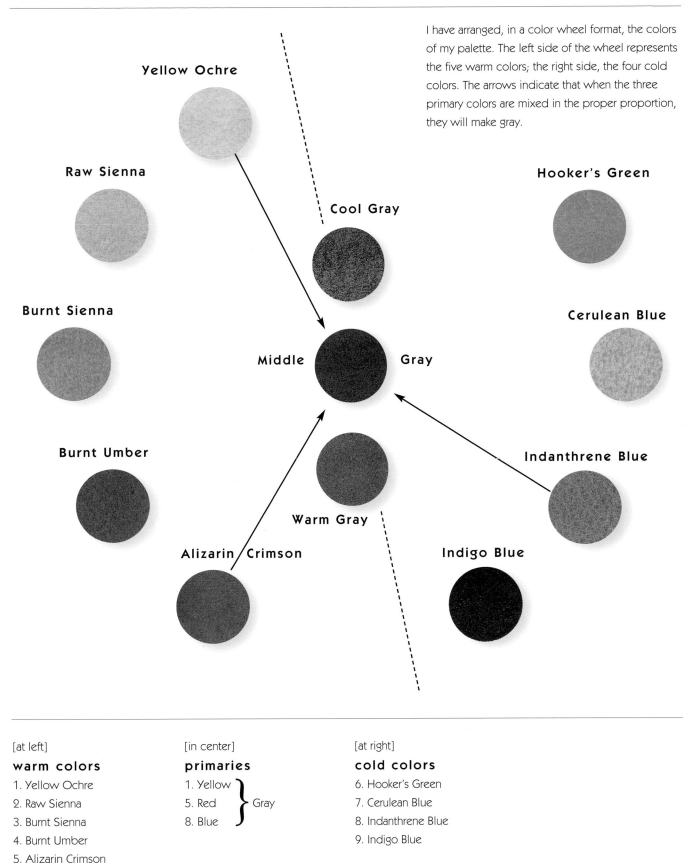

I have arranged, in a color wheel format, the colors of my palette. The left side of the wheel represents the five warm colors; the right side, the four cold colors. The arrows indicate that when the three primary colors are mixed in the proper proportion, they will make gray.

Yellow Ochre

Raw Sienna

Hooker's Green

Cool Gray

Burnt Sienna

Cerulean Blue

Middle Gray

Burnt Umber

Indanthrene Blue

Warm Gray

Alizarin Crimson

Indigo Blue

[at left]

warm colors

1. Yellow Ochre
2. Raw Sienna
3. Burnt Sienna
4. Burnt Umber
5. Alizarin Crimson

[in center]

primaries

1. Yellow
5. Red } Gray
8. Blue

[at right]

cold colors

6. Hooker's Green
7. Cerulean Blue
8. Indanthrene Blue
9. Indigo Blue

	yellow ochre	raw sienna	burnt sienna	burnt umber		alizarin crimson	

warm palette

8 wells each

	hooker's green			cerulean blue	indan-threne blue	indigo blue	

cold palette

the grays

From my conversations with students in various watercolor classes, I learned that many of them did not know that the three primary colors—yellow, red and blue—will make beautiful grays, either on the warm or cold side. This is important to know, especially when using a limited palette such as mine. Mixing grays can help you, obviously, with painting gray days and painting fog. But there are other uses for gray beyond capturing these gray conditions.

When you want to mix areas in light, you have to dilute greatly the "sunshiny" yellows: Yellow Ochre, Raw Sienna, even Burnt Sienna. When you want to paint shadows, however, you will have to mix your colors into shades of gray, made by a mixture of the three primaries.

Here are some thoughts on mixing grays. When mixing yellow, red and blue to make your grays, you need a balance of each color. By trial and error, this is something you must work out: some of this and some of that, until you come up with the gray you want, either on the warm or cold side.

CREATING GRAY

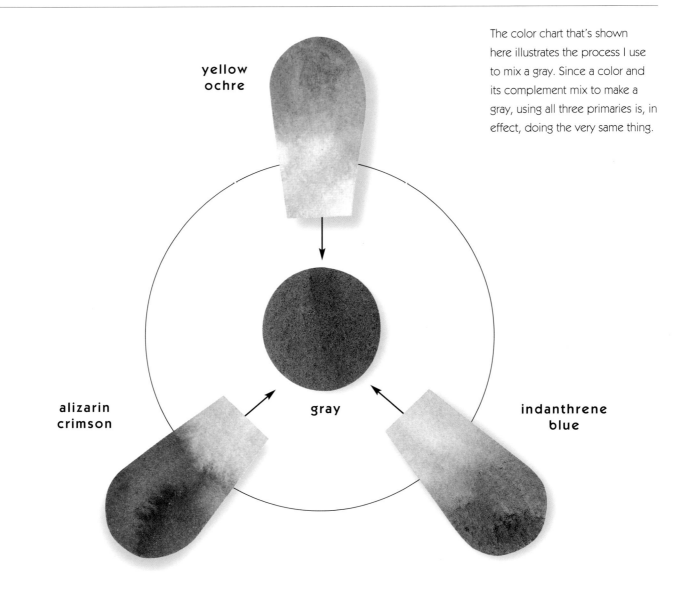

yellow
ochre

alizarin
crimson

gray

indanthrene
blue

The color chart that's shown here illustrates the process I use to mix a gray. Since a color and its complement mix to make a gray, using all three primaries is, in effect, doing the very same thing.

my palette in action

I have selected four landscapes to illustrate how
I used my nine-color palette to paint them. Study them
carefully.

red barn

22 x 30"

This painting was done in New York State's Catskill Mountains in July. The sun was very strong, and I needed to use the full value of my colors to create a contrast between dark and light. This painting is on the warm side. The red is Alizarin Crimson with a touch of Burnt Sienna. The whites are the white of the paper. The green in the foreground is Hooker's Green with a touch of Yellow Ochre and Cerulean Blue. The painting needed some movement so I created it with action in the sky.

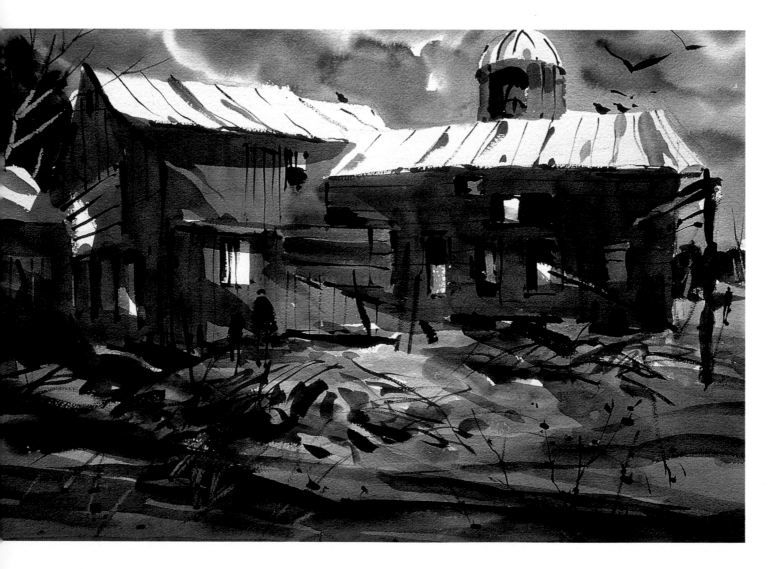

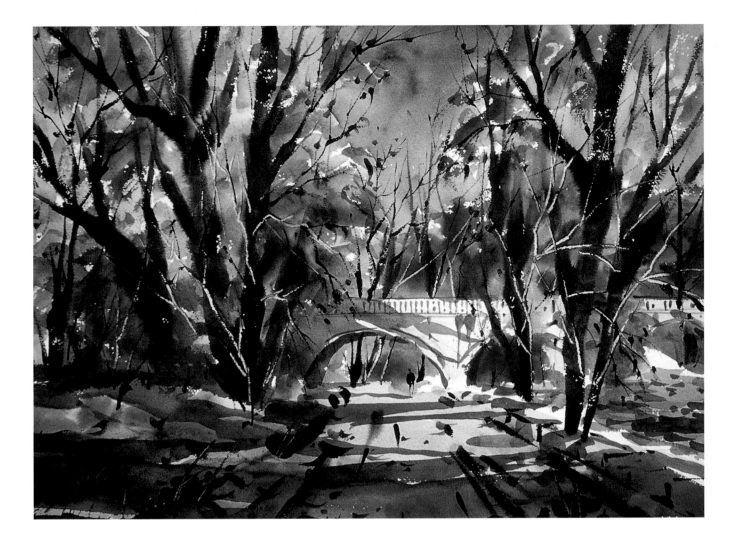

brandywine river
22 x 30"

This painting was done on the
Brandywine River, Wilmington,
Delaware, while on a painting trip
with members of the Philadelphia
Sketch Club. I was attracted to the
powerful fall colors–the red, Burnt
Sienna, Raw Sienna, Burnt Umber
and Yellow Ochre. They created a
blaze of color. The shadows were
created by adding a touch of
Alizarin Crimson to Indanthrene Blue.
The sky is quiet so as not to detract
from my vibrant colors.

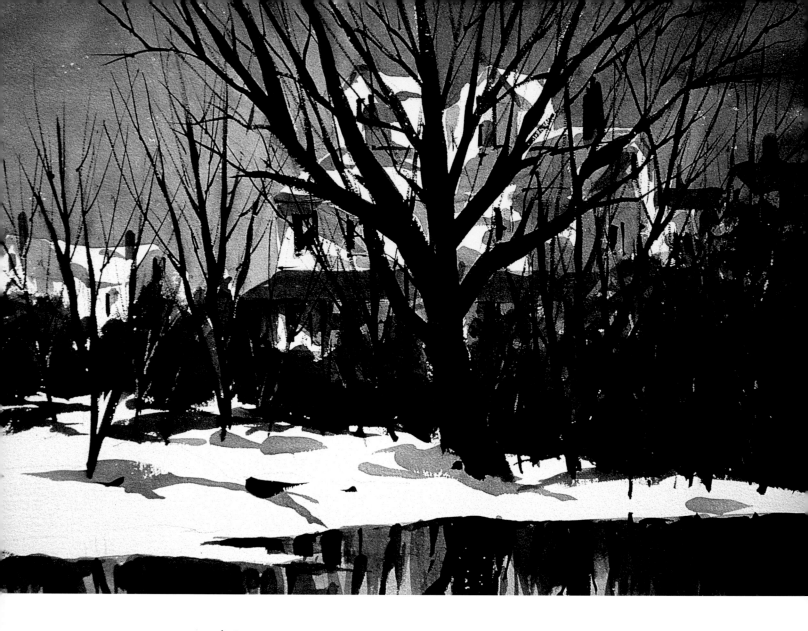

winter gray
22 x 30"

Winter colors can be cold or warm depending on the time of day, the month of the year and whether it is cloudy or sunny. This painting was done on a cold and gray day, painted as the snow was starting to melt and the reflections in place. I made use of the white of my paper for the snow patterns. The darks are a combination of blues with a touch of Alizarin Crimson.

forest light
22 x 30"

Spring is when you go outside and, for me, it gets the creative juices flowing. The winter colors are changing, the trees are starting to bloom and everything seems to be coming to life. The colors of spring are varied—you have blue-greens and warm green. The pattern of the trees reflected in the creek intrigued me when I painted this composition; there is a tunnel effect. For this painting I used Hooker's Green, with a touch of Indanthrene Blue and Cerulean Blue, plus a small touch of Yellow Ochre for a warm note. The sun created a dappling of light on the trees and water.

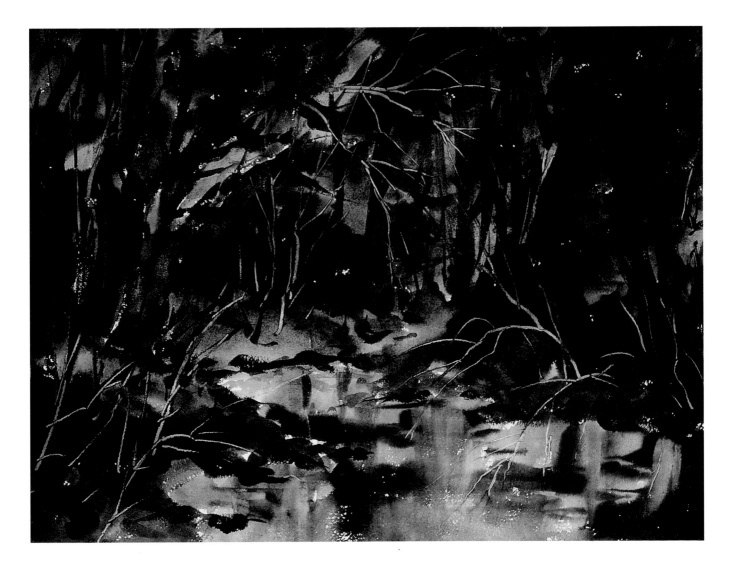

number please
22 x 30"

In this composition, it's easy to locate the focal point—
the telephone pole in the foreground on the right.

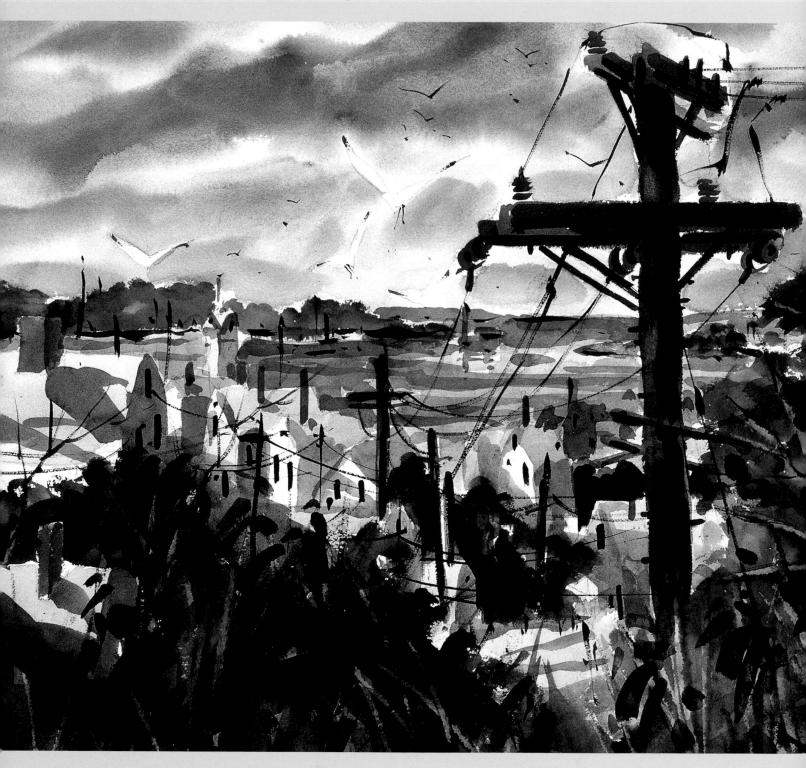

my color value scale

A PAINTING, WHETHER DONE IN WATERCOLOR, OIL, ACRYLIC OR pastel, is made up of many elements. First, it has to have a composition, which is the design, then, of course it must have a drawing to advance that design, and ultimately, it has to have color simply because we live in a colorful world.

If there is such a thing as the most important element of any painting, professional painters will tell you that it is values. Simply stated, values make it possible to run the gamut from light to dark and warm and cool. Over a period of years of teaching, I have tried to find a way to pass on to students a way for them to understand the importance of recognizing values. I have found it in the development of what I call a color value scale.

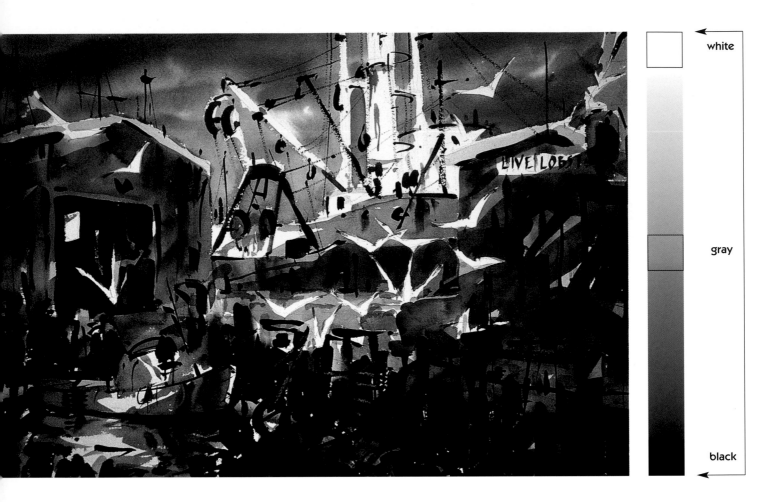

white

gray

black

**municipal pier,
gloucester, ma**
22 x 30"

When I saw this composition, I felt
that the painting should have an
abstract feeling. The overall impres-
sion of the values were from high
to low (white to black). The light
and shadows were at the right
place at the right time. This does
not always happen. I had to keep
my first impression in mind and
paint quickly because the light was
changing so fast. It was difficult to
hold the shapes and values from
white to black. The painting was
done on a gray day which helped
keep the whites at a high key and
the values under the pilings toward
the black end of the color value
chart. The mid-tones were already
in place because of the gray day.

This scale is very simple. Before I start to paint, I
take a good look at my subject matter or composition.
I then ask myself these questions: "Is it high key? Is it
low key? Is it basically warm? Or is it cold?" This analy-
sis takes but a few minutes. It gives me an overall tonal
view of the painting I am about to do. I can say that gen-
erally, most of my paintings make use of the complete
scale from high to low key. This is a personal way of
painting. This method gives me a quick reading of my
color value sketch. It also teaches me to look and see
my composition in color.

In the paintings on the pages of this chapter, you will get an idea of how this value scale works. Alongside each reproduction, I have provided a scale from white to gray to black to indicate the key each one was painted in, and graphically showing you the tonal range of each painting.

winter shadows
22 x 30"

This was a ready-made composition. The values I saw were from middle gray to black. Even though there is some light on the buildings, the overall mood is low key. You are more likely to find these color values at dusk when the sun is setting. They can be warm or cold. Although these colors appear at this time of day, you may find that you'll have to force yourself to paint low key when doing this type of painting. You probably should do some preliminary, warm-up color sketches to prepare yourself for the final painting.

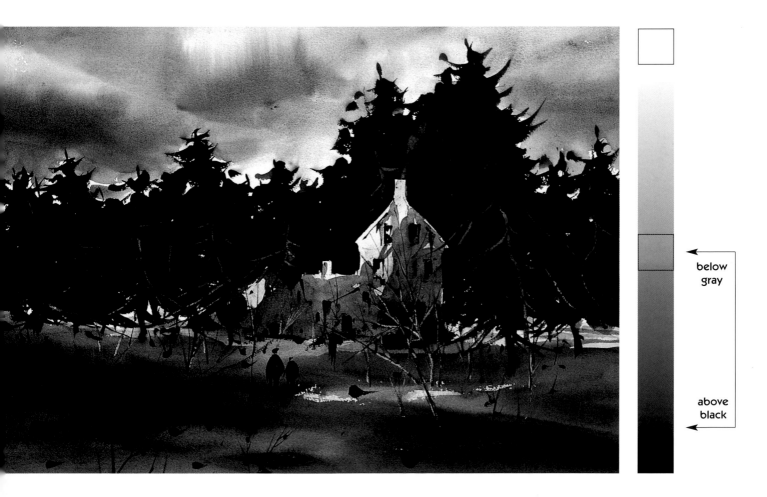

below
gray

above
black

august sunlight
22 x 30"

This painting was a happening. It was painted in mid-afternoon in the late summer. It looks like a high key composition but when you look at it more closely, you will see that the values are below white and above black (nothing white, nothing black). It is in the mid-value range. In order to give the composition more drama, I forced the warm light in the buildings. I felt that the painting needed some action, so I put some movement in the sky.

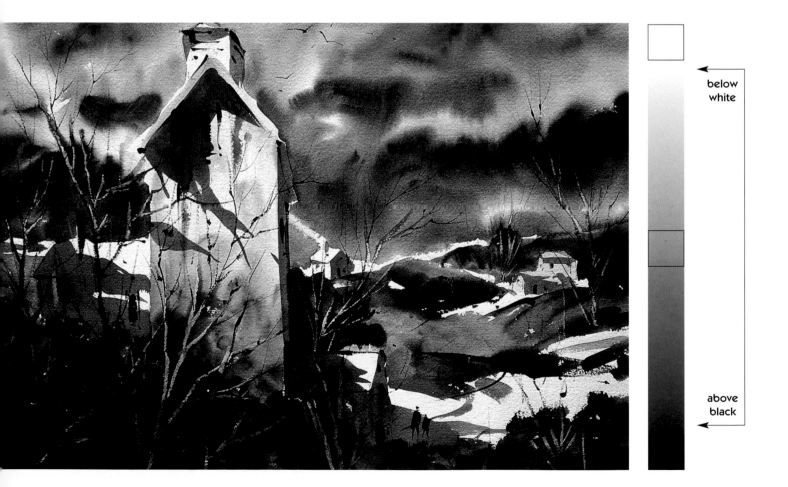

below
white

above
black

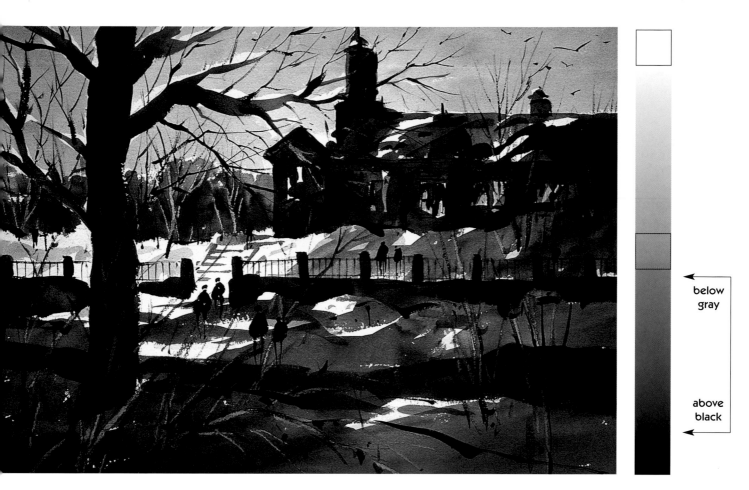

below
gray

above
black

after the storm
22 x 30"

I wanted to do this subject for some time. When looking out of my front window after the blizzard of 1996, I finally saw my composition. This is a very low key painting. All of the values are below gray to black. I used the white of my paper to force the white of the snow in order to give a cold dramatic feeling to the painting. I put a little warmth in this composition by adding light to the windows. Look closely and you will see some shapes of cars under the snow. I am enchanted by the building and have more compositions to be done in mind. I haven't put them together yet. But I will!

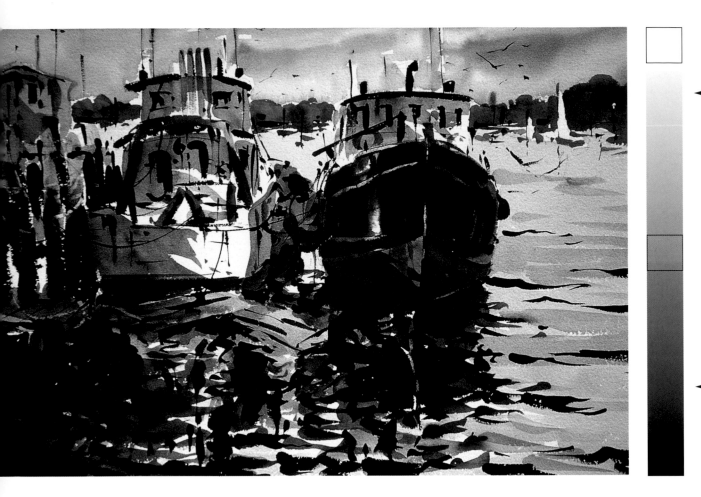

below
white

above
black

red bumpers
22 x 30"

I saw this composition just as I finished another painting. The red bumpers (or fenders) between the boats caught my eye. This gave me my next day's composition. It was mid-day and the sun was at the right place to give me good light and shadows. The light in the water gave me great dark values for the reflections of the boats and the dock area. The values are in a gray mood, below white and above black. There are several white sailboats in the background which complement the white boat in the middle ground. I was pleased with the way the shapes came together in this painting.

up in the cradle
22 x 30"

I feel that all of the values in this painting are at the mid-point between white and gray and gray and black. It just happened that way. The sky and part of the water are the same values. And you will notice that the boat and the reflections are of the same dark values and almost the same shapes. That cannot be planned so you have to invent a few shapes to complement the whole composition. Painting the cradle and the boat in this composition presented a perspective problem which I had to solve. Part of the problem is that this composition has a low horizon line which is not visible in the picture. The boat sits high in the cradle out of the water. The major problem was trying to make it look like it's resting in the cradle. (For a more detailed account of perspective, refer to Chapter 6.) I like to paint a composition like this at low tide because I like the reflections of the subject matter in the water.

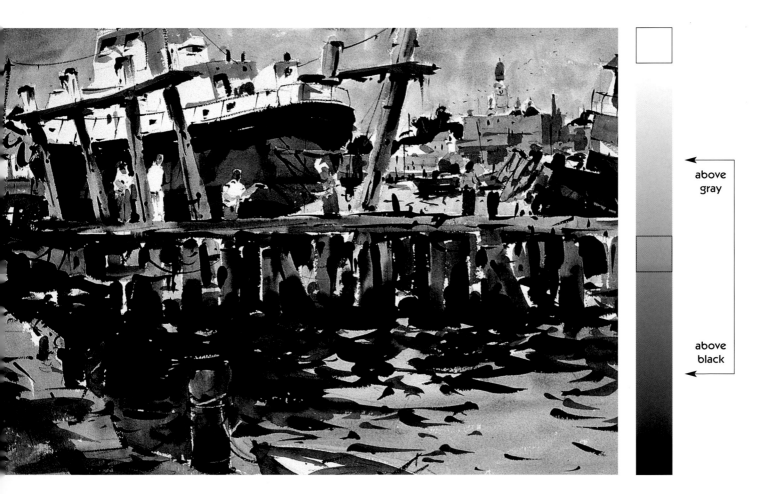

above
gray

above
black

lonely
22 x 30"

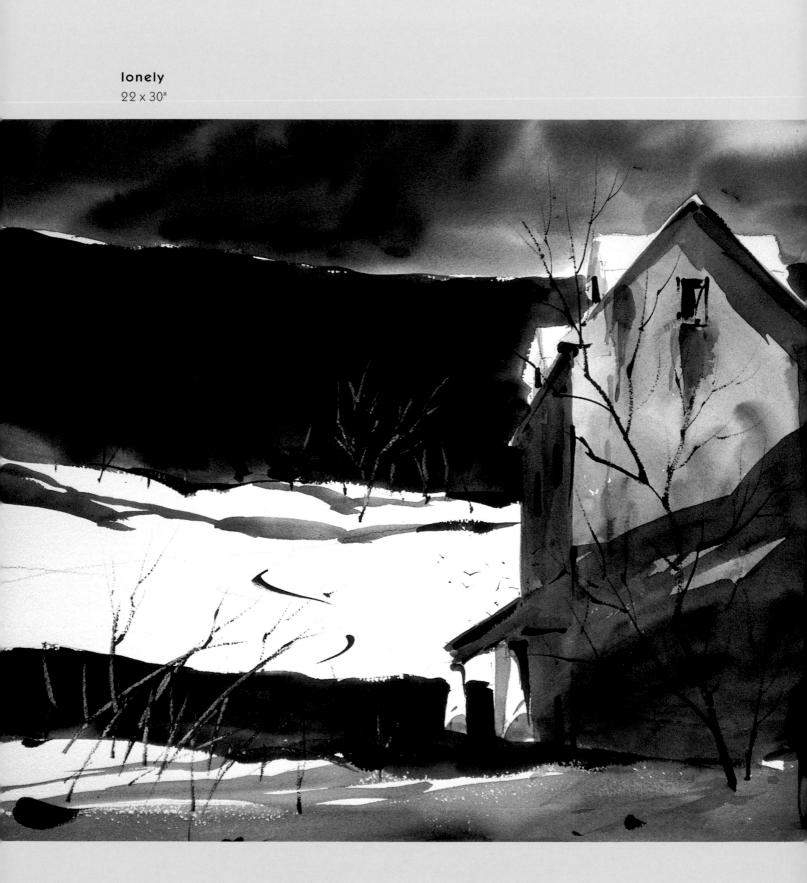

5

composition

 NE OF THE DEFINITIONS THAT BEST DESCRIBES COMPOSITION is "an arrangement of artistic parts so as to form a unified whole." In a way, it's like a jigsaw puzzle in which the shapes have to fit, the difference being that in a painting each shape has to be interesting.

When I go out on location to paint, I ask myself how many shapes do I need for this composition? Unlike a still life painter who sets up his subject matter on the model stand, then lights it to best advantage thus creating a composition, I, the landscape painter, face a vast vista before me and then must abstract it all down to a workable plan. What I see at this point is only a guide for a painting. I am not afraid to move things around since my main objective is to paint a mood and to tell a story.

Each painting I do—as does every painter— requires a different composition and a different design although, as you will discover shortly, only four options are available to me. They are what I call one-line, two-line, three-line and four-line compositions.

Figure 1.

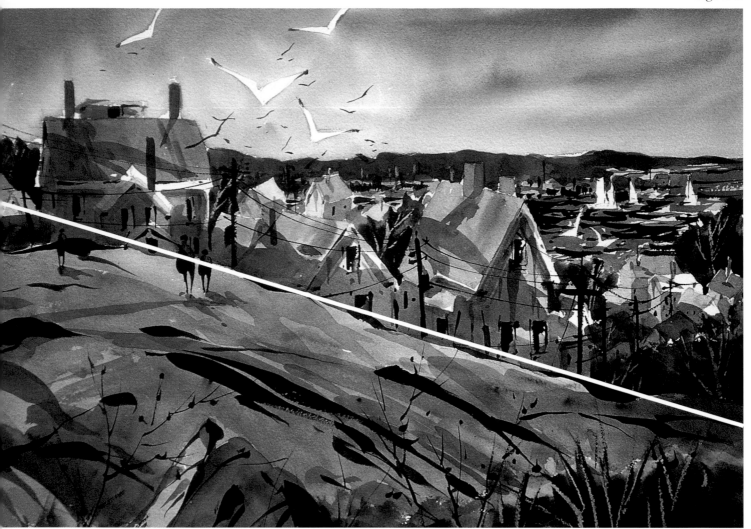

a one-line composition

view from ledgemont
22 x 30"

A one-line composition. When I first looked at this site in Gloucester, Massachusetts, it appeared to be a complicated composition. Then I started to analyze it and realized that all I needed was one diagonal line. This line, as you can see, forms two shapes, each one simple and interesting.

When I compose with any of these options in mind, I am always aware of my point of interest (or focal point) and where I want my painting's viewer to look. You will find that this will benefit you in making sure that your painting has a point of interest and that it is placed in a pivotal part of your composition.

Figure 1 is an example of one-line composition. In this painting, *View from Ledgemont*, you can see the diagonal that creates two interesting shapes. *Blue Mountain*, a painting with a two-line composition (**Figure 2**), makes use of horizontal and diagonal areas which are obviously seen as you view the painting. Two horizontal lines and one vertical line were used for the

painting *Lonely* (**Figure 3**), a three-line composition that creates six simple, interesting shapes. The four-line composition *Gloucester Street Scene* (**Figure 4**), makes use of all diagonals which are more difficult for you to detect than horizontal and vertical lines.

I need a lot of thinking and seeing before I start painting. I am concerned foremost with how simple a composition I can paint. When I finally start drawing my composition, I look at my subject matter and concentrate on shapes and also on color values. This way I know exactly what to do when I start to paint. I also try to compose by leaving shapes of white paper to help my shapes of color. There is a certain amount of beauty that is gained by leaving areas of the paper white.

a two-line composition

blue mountain

22 x 30"

A two-line composition. There is no question that this is a horizontal and diagonal composition. You automatically see the two lines when you first view this painting, a simple composition. The two lines form three shapes.

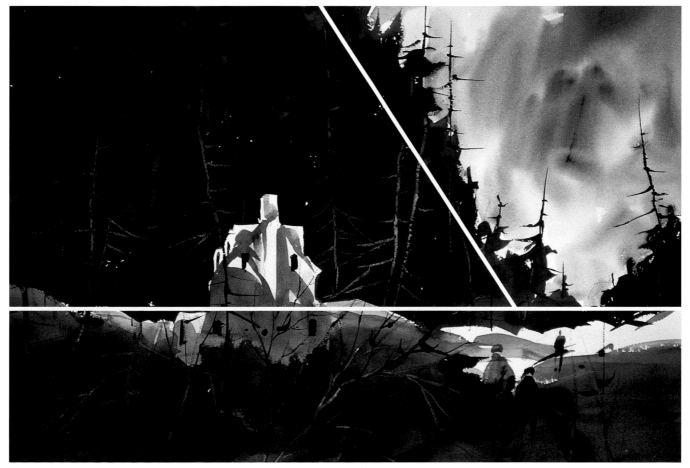

Figure 2.

Figure 3.

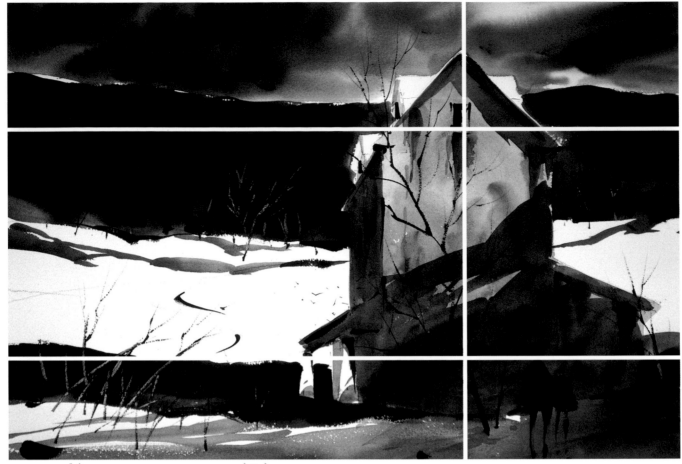

a three-line composition

lonely

22 x 30"

A three-line composition.
It has two horizontal lines and
one vertical line. At first glance,
it may look complicated but it is
not. The three lines are used to
form six simple shapes.

Uppermost in my mind is where my point of interest will be, and that is where I want my painting's viewers to look. To do this, I strategically place vertical and/or horizontal lines, which I call "stoppers." An example of how I used stoppers can be seen in my painting *Inner Harbor* (**Figure 5**). I expressly designed the vertical of the mast of the sailboat on the left and the vertical mast of the small boat on the right to stop the eye from roaming beyond the image area, hence the name "stoppers."

I also use for some paintings a series of directional lines that will keep the eye looking at the point of interest. An example of this is **Figure 6**, my painting *Under the Bridge*, which is a composition of single point perspective.

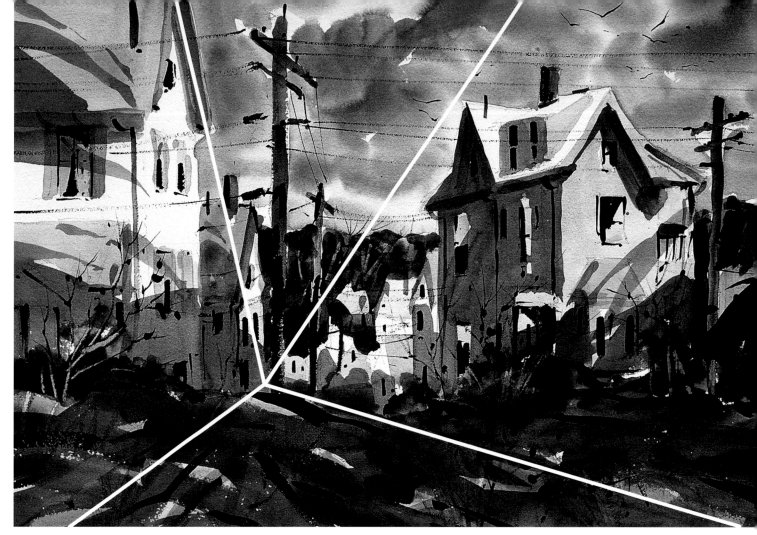

Figure 4.

The methods that I used in the paintings in this chapter will work with any subject matter. You will need a lot of thinking and seeing before you start painting. You should be thinking about how simple a composition you can paint. My paintings pictured here and throughout this book show you what can be accomplished with just a few simple lines. They also illustrate simplicity of shapes.

If you are not used to painting outside, get your sketch pad out and see how you can reduce the panorama that's spread out before you with just some simple lines. Say to yourself: I can paint this composition in one line, two lines, three lines or four and then do it. It teaches you how to keep your shapes simple.

gloucester street scene
22 x 30"

A four-line composition creating four interesting shapes. As you can see, all four lines are on a diagonal. This is a more complicated painting because diagonal lines are not as easy to see as horizontal and vertical lines. It required more looking and seeing. While this is more difficult to accomplish, the result is very rewarding.

a four-line composition

inner harbor

22 x 30"

Composition stoppers are lines that help keep the eye inside the painting and focused on the point of interest. Stoppers can be vertical or horizontal and a number of objects—animate and inanimate —can be used as stoppers: trees, houses, figures, animals, etc. In this composition, I used two lines as vertical stoppers. The one on the left is the sail of the large boat; it keeps the eye from going out of the left side of the composition. The mast on the small boat keeps the eye from going out of the right side of the composition. The point of interest in this painting is the two boats. Stoppers can also be used to keep your eye from going out of the top or bottom of a painting.

composition stoppers

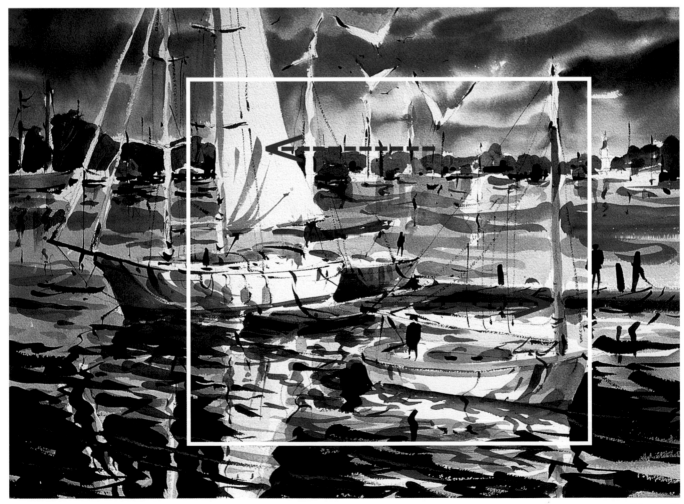

Figure 5.

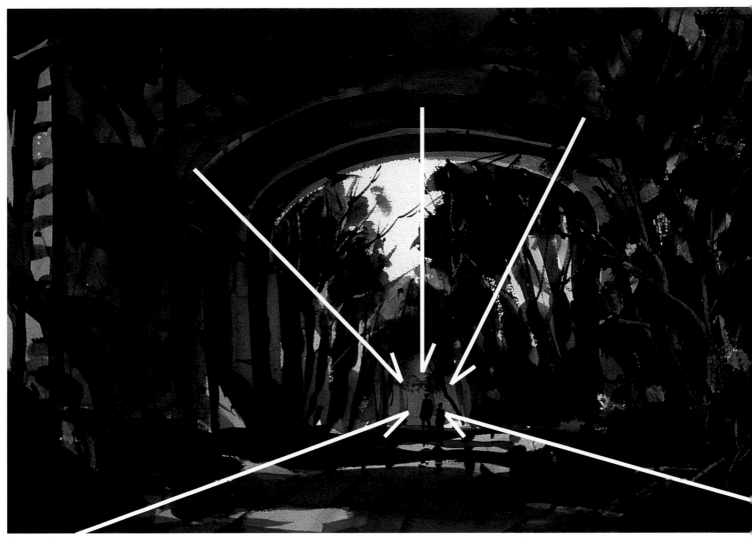

Figure 6.

under the bridge
22 x 30"

Composition directional lines are designed to keep the eye looking at the point of interest. A rather simple composition, it is a single point perspective with all the lines going to one specific area of the painting. I did this painting while standing in the middle of the road focusing on the dramatic light and shadows. The lines were obvious so I could not miss the simple directional lines. Your

directional lines should focus somewhere toward your point of interest. You can use all sorts of lines: tree branches, road lines, hands pointing, to name but a few. You can also use color or a shape as a directional line to make the viewer look to the point of interest. This will vary in different types of compositions. Don't be afraid to experiment with directional lines.

directional lines

gloucester square
22 x 30"

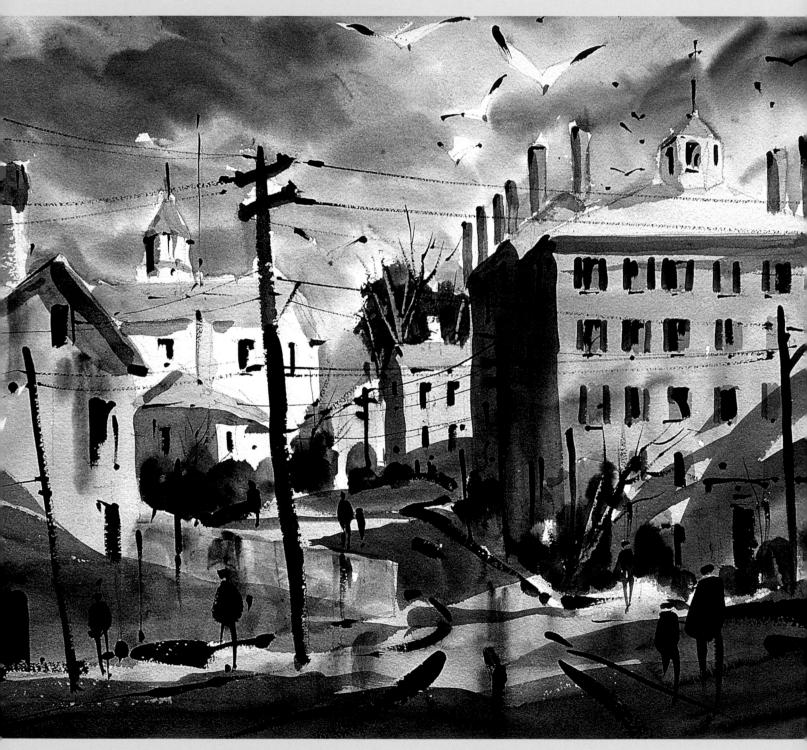

6

drawing & perspective

RAWING IS EXTREMELY IMPORTANT, BUT YOU HAVE TO recognize and respect its function as a factor in painting. An oil painter friend of mine used to tell her students, "You draw a drawing; you paint a painting." Very wise and very true. Even though it would seem that her observation applies more to painting with oil colors, where all evidence of your drawing eventually gets covered up, it also is valid in watercolor painting. As you know, your pencil drawing will show through the transparent colors of the painting, which means that your drawing has to be kept to a bare minimum. After all, you are "painting a painting."

Everyone needs a good drawing to start a composition. I have trained myself to do the least amount of drawing as possible. In essence, I just draw the important lines or sometimes just a suggestion of the important lines. If architecture is involved, then, obviously, I have to tighten my lines to be sure that the subject matter looks right.

The main reason why I make the least amount of lines is that I don't want to be bound by those lines. They are just there to guide me in the right direction. I have the option of painting above or below the lines or even of changing the shapes as I paint. That's why the pencil lines that have made those shapes have to make the faintest kind of statement.

Don't get the wrong impression and think that drawing is incidental; it is not. Drawing is an essential part of your work; but you must think of it as only scaffolding for the painting that you will do on top of it. If drawing is not your strong point, I can only urge you to practice: draw, draw, everything and anything. Get all the instruction you can. The more you draw, the better you become. Drawing will become second nature to you. The thinking should be the same whether you draw in the studio or outside.

I give my students a perspective target around the vanishing points because you sometimes have to adjust the perspective lines toward your vanishing points or target in order to make the drawing look right and not distorted. I do this myself when I am out in the field painting. Your painting will suffer if your drawing and perspective are not correct. "LVP" and "RVP" on diagram denote left and right vanishing points.

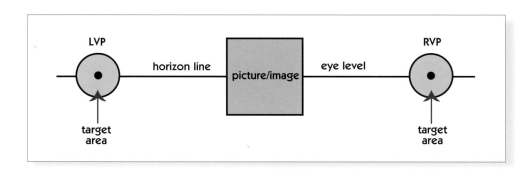

perspective

The feeling that I get about my students as they paint, is that they are involved, engrossed in their work, and, generally, pleased. Except, that is, when they are called upon to use perspective in their compositions. In this area, the students are faced with a mechanical necessity that, they fear, will threaten to squelch their creativity. Suddenly, they are aware of eye levels, ellipses, horizons, vanishing points, all terms that are more engineer-like than artistic.

I want to say just a few words about perspective. I have to emphasize just how important perspective is to your drawing. Drawing and

SINGLE POINT PERSPECTIVE

horizon line eye level

image area

This diagram is of single point perspective, showing that all horizontal lines are parallel to the horizon line. All lines that are in perspective go to your single point which can be anywhere along the horizon line. It should always be somewhere within your image area.

think horizon line for all
of your perspective points

perspective do go hand in hand; you can't have one without the other. But here's another bit of advice: learn just enough perspective to use in landscape painting. Perspective can be awfully complicated, but when you concentrate on only the bare essentials, you will find that it's painless and even enjoyable, because it will make your drawing and painting more plausible.

A good place to start is the horizon line. There is only one horizon line— not two or three—just one. How do you find the horizon line? It is very simple. Extend your arm while holding a pencil at eye level—always at eye level—not up or down. This is true whether you are standing or sitting. If your subject matter is above the horizon line (or eye level) you have a low horizon line. If the subject matter is below the horizon line, you have a high horizon line. When you are looking above your horizon line, your lines go down to your vanishing points. For anything below your horizon line, your lines go up to your vanishing points, which are always on the horizon line. (Refer to page 60.)

The placement of the vanishing points along your horizon lines is optional. You can put them anywhere you want. If there is a change of angle in your subject matter, you will require another set of vanishing points for just that shape. Use the same horizon line. The horizon line never changes.

When looking down, perspective lines come up to the left and right vanishing points.

When looking up, perspective lines should come down to the left and right vanishing points.

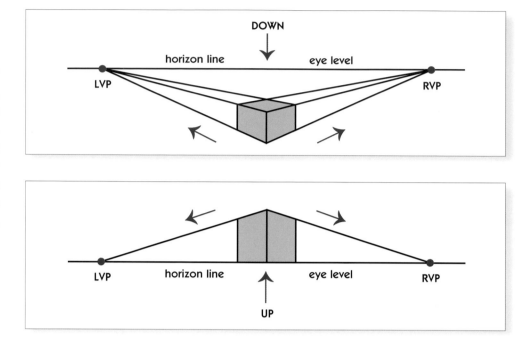

Think horizon lines for all of your perspective points. Remember, your perspective points can be anywhere on the horizon line. It's your choice. They do not have to be equally spaced. Your composition should dictate where the vanishing points should be located.

Vanishing points do not have to be equal off a center line. They can vary in distance—left or right. I give my students a perspective target around their vanishing points because sometimes you have to adjust the lines toward your target to make your drawing look right and not distorted. Most of the time, you will discover, the vanishing points will be outside your painting image so this is where you do the adjusting. Basically, your drawings will use one- or two-point perspective, very rarely three-point. And going beyond three-point perspective gets difficult.

FINDING THE HORIZON LINE

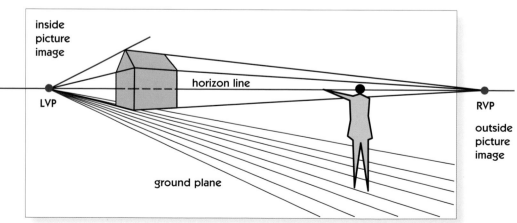

To find the horizon line, hold a pencil or brush in your outstretched hand at eye level. Never up, never down. This applies whether you are standing or sitting. Bear in mind that you only need one horizon line, not two, not three. And it's your choice: high horizon line or low horizon line. Your perspective points are always on the horizon line, inside the picture image or outside, as shown in the illustration.

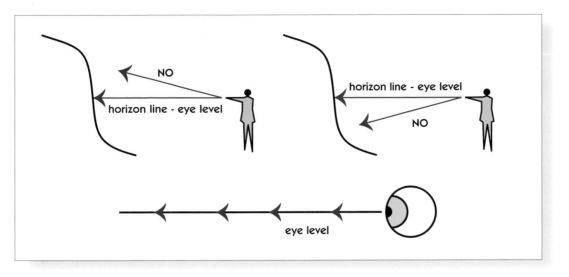

NO

horizon line - eye level

horizon line - eye level

NO

eye level

Your horizon line is always at eye level. Never up or down. This applies whether you are standing or sitting.

My diagrams have been designed to give you a better graphic concept of how I approach the use of perspective in my outdoor paintings.

HIGH HORIZON

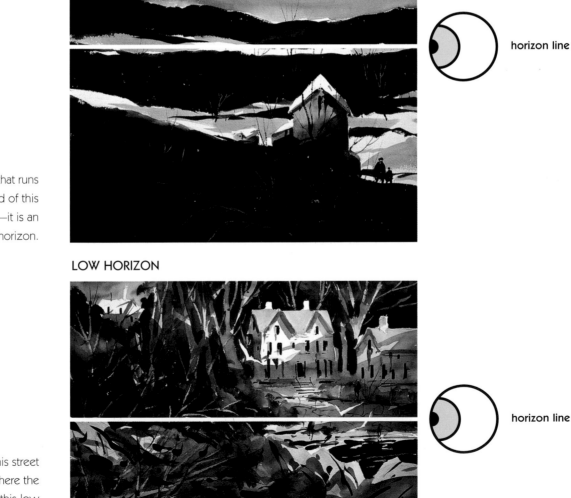

horizon line

The white line that runs across the top third of this winter landscape—it is an example of a high horizon.

LOW HORIZON

horizon line

The lower third of this street scene—indicates where the horizon line is on this low horizon composition.

at the fort, gloucester, ma
22 x 30"

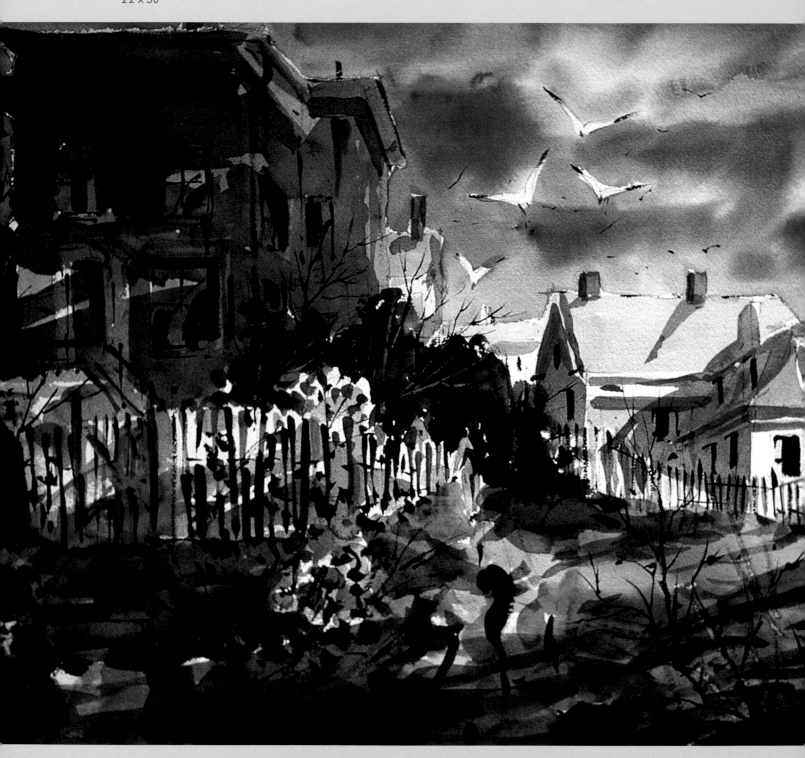

7

painting
spring
When Color Comes Alive

TO MANY PEOPLE IN THIS COUNTRY, THE COMING OF SPRING IS a rebirth. After the harsh winds, low temperatures, and snow accumulations of winter, weather-weary souls are anxious to shed heavy outer garments for lighter cover to scamper outdoors to manicure punished lawns, and to hit the flower beds.

As promising as spring is to so many, to the landscape painter, it is a time that can be loaded with difficulties. The colors of spring, you see, are hard to paint, because they are in a period of transition: too much green will give you summer; too much blue will give you winter. You have to be careful of your color values. In order to do this you have to strike a balance of warm and cool colors.

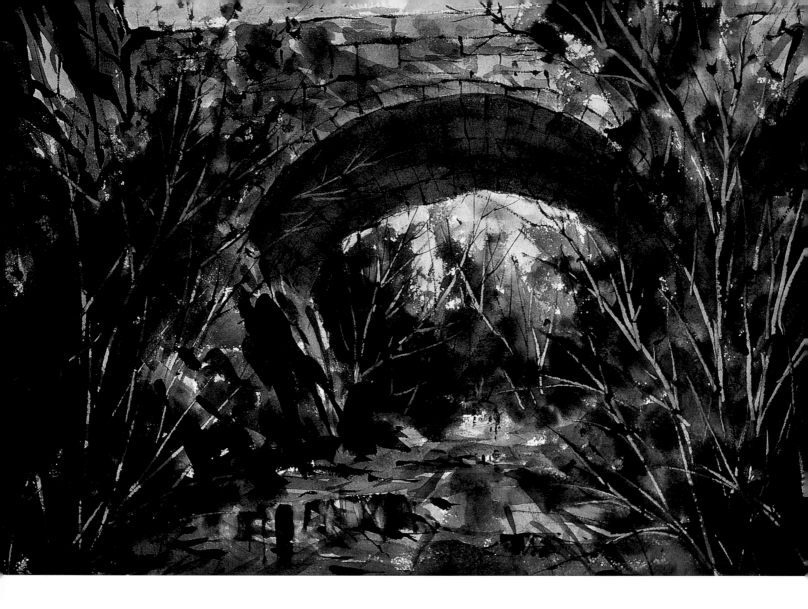

quarry bridge
22 x 30"

The green in this painting is almost a summer green. I used a blue-yellow combination, favoring the blue. There are good things happening in the green because I used shapes within shapes. Some artist friends call the use of this amount of green "spinach," and won't paint it.

I love it! It is a challenge. The height of the bridge interested me as well as the tunnel-like opening, which is a single-point perspective with a low horizon line. The underside of the bridge is reflected in the water in the road and actually enhanced the composition.

It gets tricky. When I paint spring green, it is not the green that instantly comes to everyone's mind; it is a chromatically reduced green that is made from a mixture of Yellow Ochre (can also be Raw Sienna) and Cerulean Blue. My green mixture is my personal choice. Each artist's choice is different.

Spring shadows can vary from warm to cool, depending on the time of the day. For my shadows, I usually favor gray lavender on the blue side. To make this, I mix Alizarin Crimson and Indanthrene Blue.

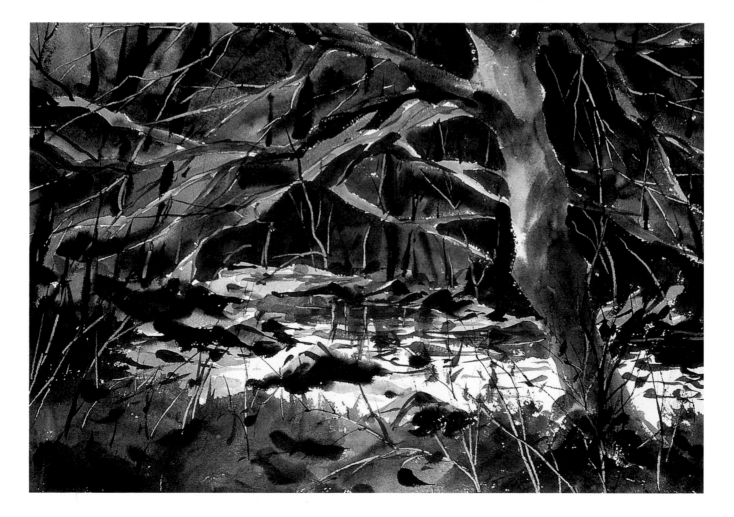

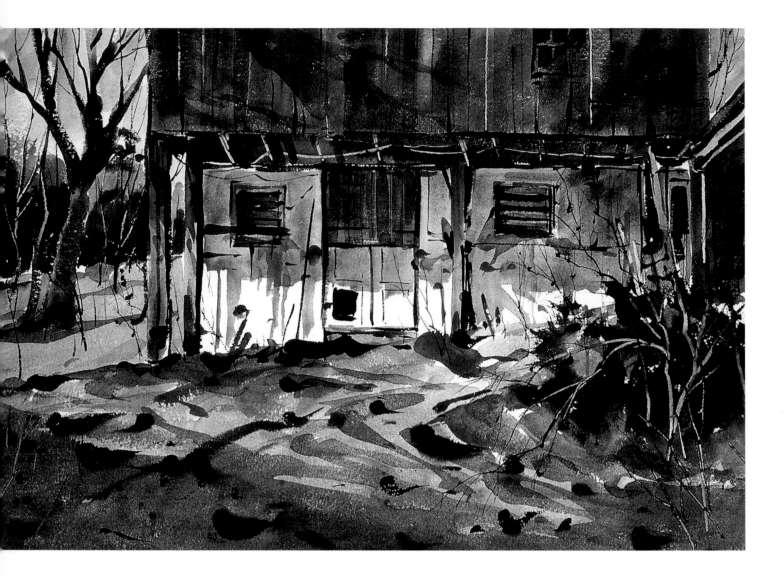

jim's barn
22 x 30"

This painting was done during a Philadelphia Sketch Club outing. The barn belongs to my friend Jim. It was a day in early spring. The buds were just starting to appear on the trees; I got the feeling that spring green was just around the corner. The white on the barn doors became my point of interest. I used the dark notes around them to help the viewer focus on them. The more I painted, the warmer the composition became; this included the shadows. I kept a hint of sky in the upper right and upper left hand corners to inject a feeling of distance. The painting is a one-line composition (refer to Chapter 5, Composition), creating two large shapes: the barn and the foreground. I tried to keep this composition as simple as I could.

late spring
22 x 30"

Spring green was all around me when I arrived at this location. I started this composition as a spring painting and ended up as an early summer painting. I changed my thinking in midstream. This sometimes happens. The more I painted the deeper my color values became. The greens I used were on the warm side: Hooker's Green and Burnt Umber. I did not use any blue-yellow combinations. I came back to this location a few days later and did a spring painting. I had to create and invent some of the shadow shapes to bring my eye to the barn, which is my point of interest. In this picture, there is a full range of color values from white to dark

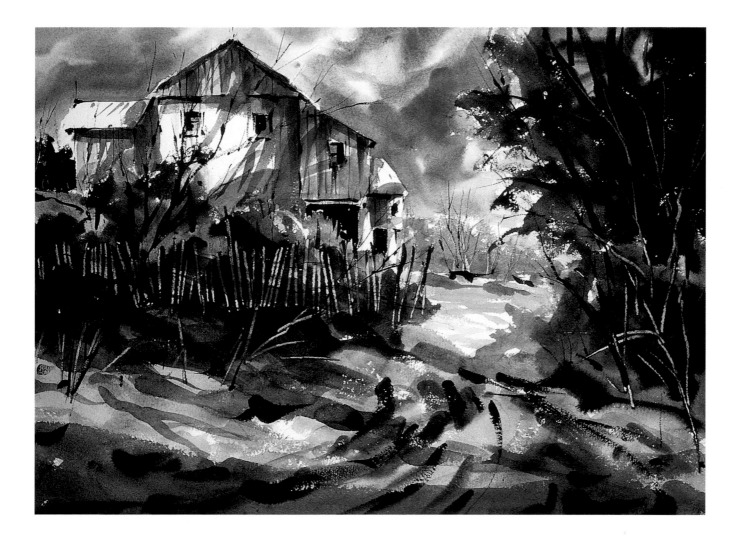

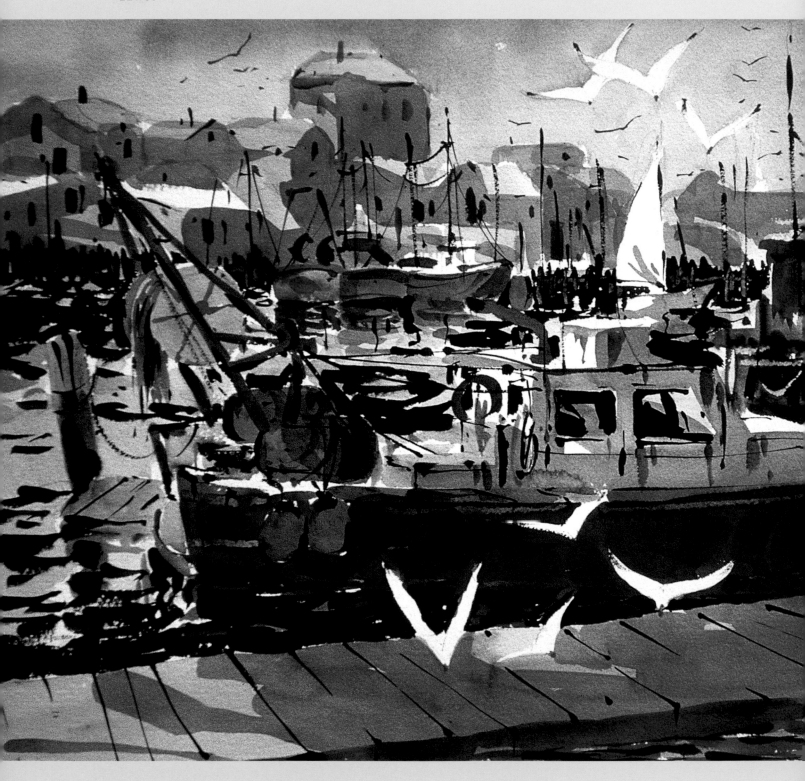

8

painting
the Lush Season of
summer

THINK I MAY BE RIGHT IN PROCLAIMING THAT EVERYONE loves summer. For many, it's vacation time. Swimming, boating, golf, tennis, cookouts are the outdoor activities for the multitudes, anxious to color up complexions that have been paled by winter grayness,

I can safely say that summer is my favorite season. For one, I have access to more painting locations. Then, keep in mind the great advantage of having longer days. Finally, the summer light is the landscape painter's best friend.

Not all artists agree with me. Some of them think that summer is "too green," thus making it too hard to paint. I enjoy painting green. I don't use a blue-yellow mixture for my greens. I choose to use Hooker's Green, and I can make it warm or cold. For warm greens, I mix in Burnt Umber; for cold greens, I mix in a touch of blue. I make use of my full range of colors.

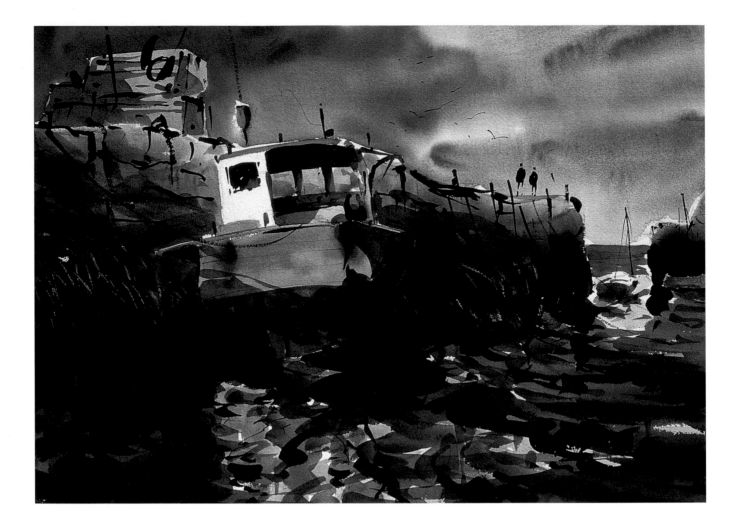

in for repairs
22 x 30"

I did this painting at Lane's Cove on Cape Ann, Massachusetts. I had to wait until the tide was low and the sun in the right place before I began painting. I was fully mindful of how important time was to me; I had to keep my eye on the incoming tide. I then started to paint. It was important to force the shapes and values of the shadows in order to make the white and green of the stern dramatic. I was painting at low tide and kneeling on a gravel bottom. Looking up constantly, I kept in mind that the horizon line was low. The finished product is a summer painting in which green is not the predominant color. It wasn't until I had finished this painting, and stood up, that I realized that I had been working in a very damp place!

Whether a day in summer is sunny, cloudy or rainy, summer landscapes are beautiful to paint. They do, however, present the painter with atmospheric problems. The major obstacles are the heat, humidity and the resulting dampness, which has a dramatic effect on your paper. 1) Your paper may get too hot, making your paint dry too fast. Overcome this by loading your brush with extra water and color. 2) Or you may be working in extremely humid conditions, wetting up your paper with too much moisture. Compensate for this with less water and more color.

The biggest problem is one that discourages a number of beginning painters, along with a few that are more experienced. It involves the creature comfort zone of the individual.

summer in canada
22 x 30"

On a painting trip with friends, I painted this scene at a lakeside resort in Canada. It was a composition that was ready-made for me, just begging to be painted. I was intrigued by the mass of green trees against the sky and the reflections in the water. Here is a very simple three-shape composition: trees, sky, water. As you can see, it's a painting that may not be for those who don't like green. But green is what summer is all about. Incidentally, this composition can be adapted to the other three seasons.

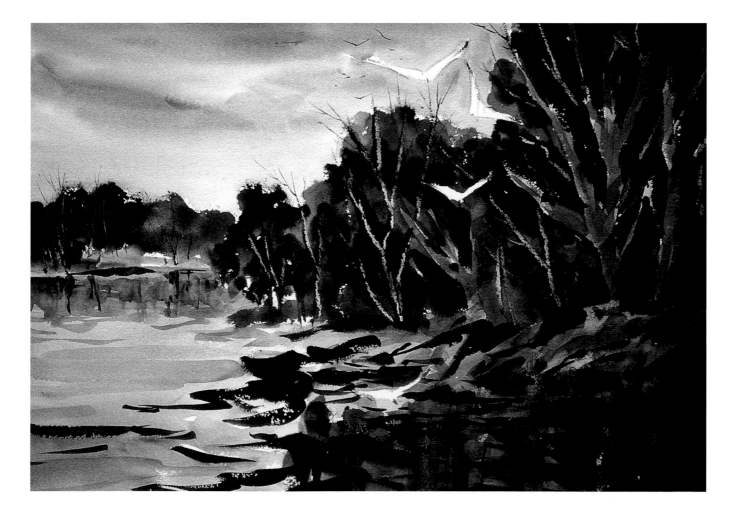

The sun, as you are quite aware of, is an ever-present annoyance; use a sun block, a wide-brimmed hat, and dress comfortably. Then, uninvited to your idyllic painting sessions, can be the insects. Aside from the mosquitoes and other flying and non-flying pests, you may get visits from bees, who are attracted to perfume, hair spray, shaving lotions, etc. Finally, every day that you go out on a summer's day, don't forget a thermos of liquid for drinking.

Be brave, for when you return from your day of painting and spread out the wonderful watercolors you produced, despite the various adversities, you will glow with immense satisfaction.

crumb creek
22 x 30"

While out for a Sunday drive, I was attracted to this scene. The dappling of light on the tree trunks intrigued me. Once on location, I knew I had to paint quickly because the light changes rapidly. I had to be sure to get the shadows and light in the right places. There are more shadows than light in this painting which makes it dramatic. While the painting appears to be cold, a careful examination will reveal that it is warmer than it seems to be at first. I paint in this area often because, no matter what the season is, there is always a new composition for me to interpret.

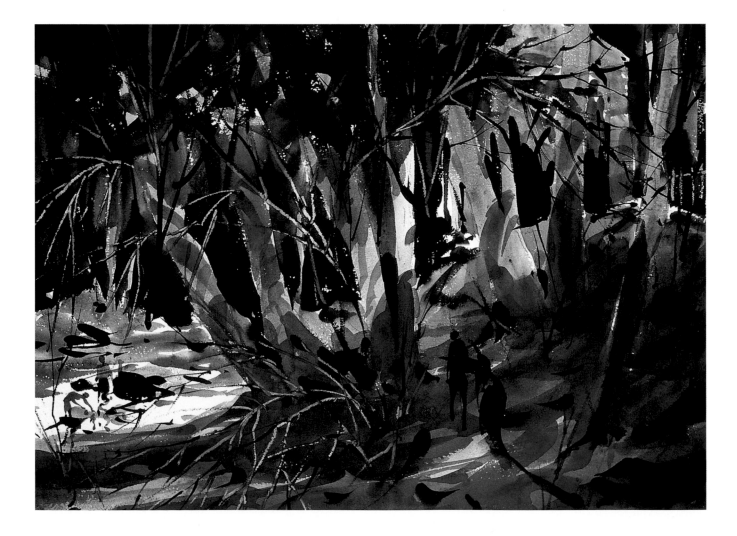

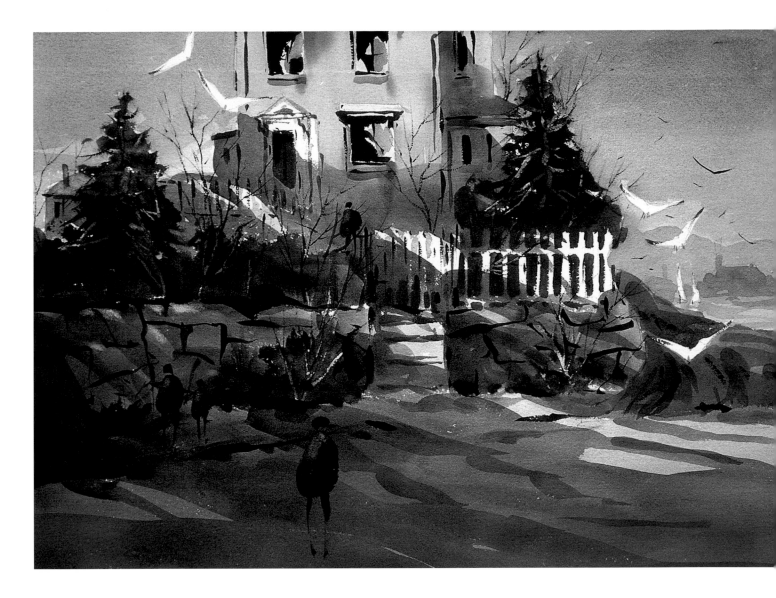

morning sun

22 x 30"

In Gloucester, Massachusetts, there's a section that's called the Fort. It's a great place to paint because the morning light gives a special glow to the subject matter. The morning I painted this picture, everything worked together. The sun, the weather and even the seagulls, in good voice that day, all combined to make great music to paint by. I let the house go out of the top of the composition; this enhanced the design and gave me stimulating shapes to work with. Interestingly, even though you can't see it, you get the feeling that the ocean is nearby. I consider this a warm painting. It has a quiet sky because I didn't want the sky to overshadow the light in the building. The white fence is also a source of light. I surrounded the middle ground and foreground with heavy shadows so the viewer's eye would go to the building, which is the source of light and is my point of interest.

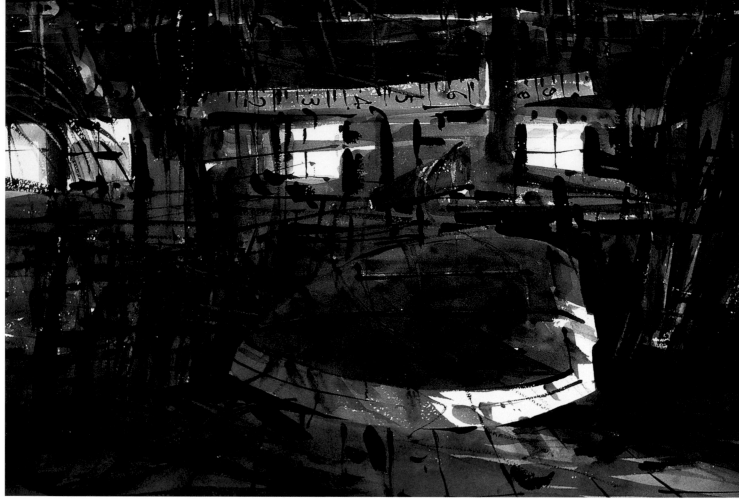

Figure 1.

overturned rowboat
22 x 30"

Green does not have to be your predominant color for summer paintings. In these two paintings, done under the sheds in Gloucester, Massachusetts, summer light and shadows are featured. Summer light is strong and you get the entire color range from light to dark.

What caught my eye in *Overturned Rowboat* (**Figure 1**) was the light on the corner of the rowboat and the light coming from the open windows. The whites are white and the darks are dark in this painting. This is a very busy painting, and you will find that my color values are on the blue side with a slight touch of warm notes, which complements the blues, on the bottom of the rowboat.

The paintings—**Figure 1** and **Figure 2**, *Open Door*—are similar but you get the feeling of more light in **Figure 1**. While **Figure 2** started out as a cold painting, it ended up as a warm one. The values are middle to dark in both of these paintings. They are also low key paintings, which I feel are hard to do.

Figure 2 is also busy. It had rained early in the morning and the deck was wet, giving me some good reflections that enhanced the composition. The real source of light came from the open door. This gave the painting a feeling of distance and openness.

I go back to this spot again and again and never tire of it. There is always something new to paint.

Summer light is strong and you get the entire color range from light to dark.

open door
22 x 30"

Figure 2.

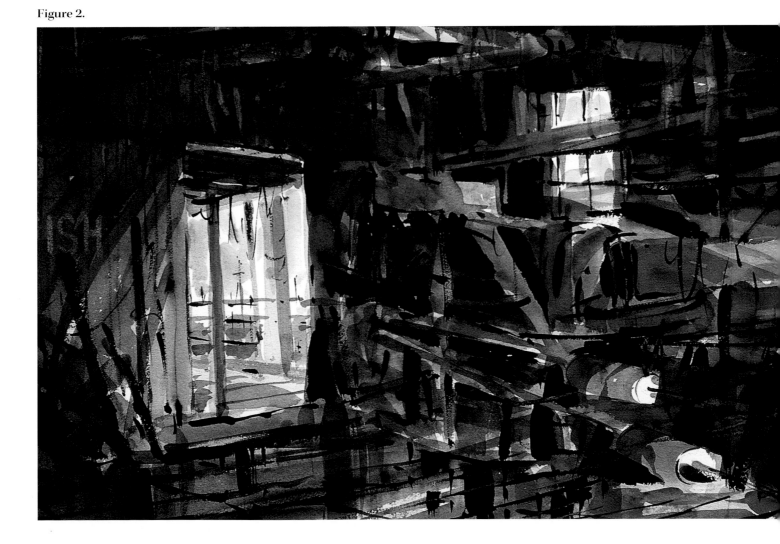

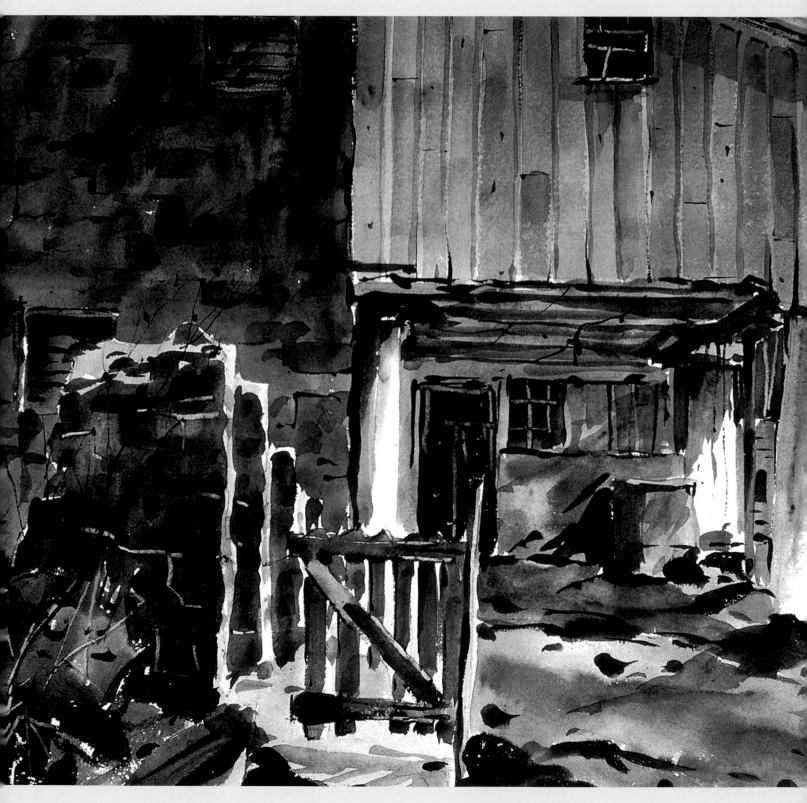

9

painting
the Glorious Colors of
autumn

URING THE FALL SEASON, HIGHWAYS IN NEW ENGLAND, New York State, the midwest states, and other areas in this vast country, choke with tourists happily willing to suffer traffic jams to glimpse at the foliage. The beauty of fall (or Autumn) sings to the artist. At its peak, the glorious colors are at their most vibrant.

It is understandable that there are artists who are sometimes reluctant to use vibrant colors. Fall cries out for pure colors and artists at times have a tendency to add other colors and end up losing brilliancy. Their colors become dry and opaque. It is incumbent upon landscape painters to keep their color values fresh and clean. They must use fresh pigment all the time. And since the vibrant colors of the season are relatively short lived, the artist must capture them at their peak.

In my palette of colors, I normally have the colors of Autumn. They are the yellows and reds of the season: Yellow Ochre, Raw Sienna, Burnt Sienna and Alizarin Crimson.

For my shadows, I paint them the same way as I do when painting spring. The shadows vary from warm to cool depending on the time of day. I favor a gray lavender on the blue side and use Alizarin Crimson and Indanthrene Blue for the shadows.

Fall has another side that occurs after the colors have peaked; it's just as interesting to paint as are the colors at full peak. The paintings that I do at this time are usually low key ones, prefacing a hint of winter. The colors I use for these paintings range from Burnt Sienna to Burnt Umber with a touch of Alizarin Crimson and Indanthrene Blue.

The shadows will be on the warm side. I've got to be careful not to paint too much winter into my composition. I prefer doing the low key paintings of fall. The off-beat colors that I find at this time of year are sensational; I love working with them.

a step-by-step demonstration of a fall scene

STEP

I did a little extra drawing for this painting. I had to show some extra detail on the building. I try to do the least amount of drawing as I can in my initial preparation. I usually do my drawing with my brush while painting. In this case, I had to tighten up on the drawing just a bit.

PALETTE
Raw Sienna
Burnt Sienna
Burnt Umber
Alizarin Crimson (just a touch)
The whites are the white of the paper

For this painting of fall, I favored the use of the earth colors of my palette. In the shadows, there's a hint of gray lavender. These are the colors I use.

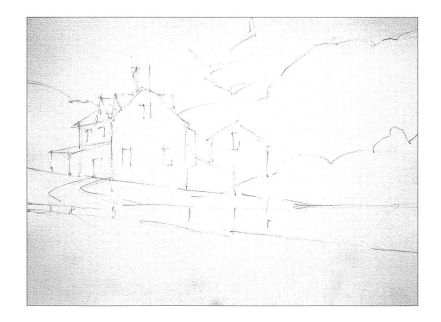

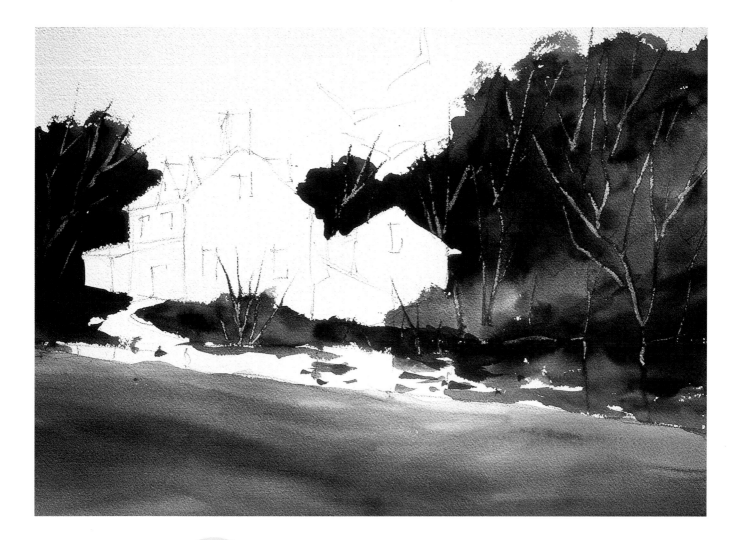

STEP 2

I wanted this painting to have the fresh, vibrant color of fall so I basically used more pure color. It helps all paintings to keep the colors clean. This means using fresh pigment all of the time. I put the vibrant fall colors in the background trees and in the foreground at the same time so I would not lose the essence of these colors.

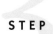**STEP** *I put most of this painting in shadow to hold the whites so they would pop out and give the painting a dramatic look.*

I put most of this painting in shadow...

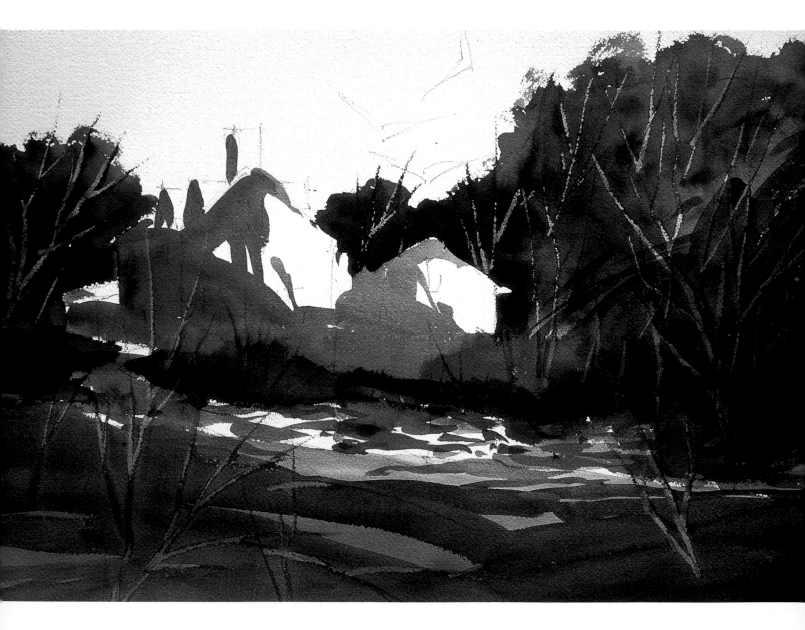

painting of fall
22 x 30"

STEP **4**

This painting had to have a warm sky. Putting in a cold sky would have split the painting in half. I put the reflections in the water at the same time I painted the trees and shadows so I would not forget them. If you have ever done this, you never want to do it again.

fall at its best
22 x 30"

Getting to this location with all of my equipment was almost impossible to do. I feel it was worth the trouble. First, I was impressed by the glow on the building and in the reflections. My first impression of the scene was that the painting would be on the warm side. The sun was moving fast, so I had to remember where the light and shadows were and invent some light-and-shadow shapes to enhance the composition. I used the colors and values from the warm side of my palette. I put in warm shadows because I felt that they were needed and added the reflections to help inject more interest. When I initially looked at the scene, I wanted to do a dramatic and strong painting. I think I succeeded.

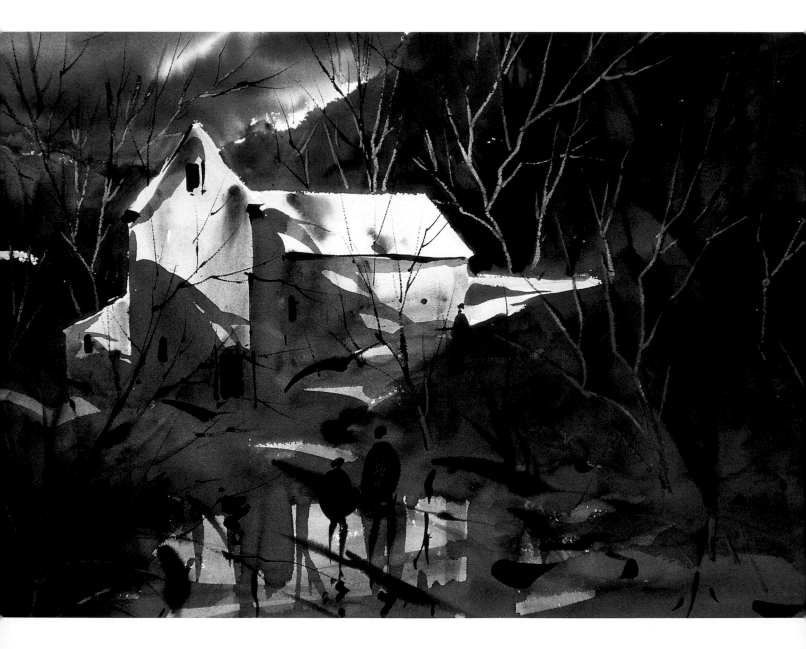

along the banks of ridley creek

22 x 30"

I was impressed by the large tree trunk and the warm fall light that illuminated the scene. I had to keep this simple, using the tree trunk as my point of interest. Sometimes we lose the simplicity of the composition by looking into a painting too deeply. I helped this painting along by exaggerating the light and shadow shapes, which dominate this painting. I always think of my subject matter as only a reference, and use it to create my interpretation of the painting location. Keep this advice in mind for all of your paintings. Do it your way! After all, you are the artist.

In these two pictures...
I used the complete value scale
from light to dark.

fall in delaware #1
22 x 30"

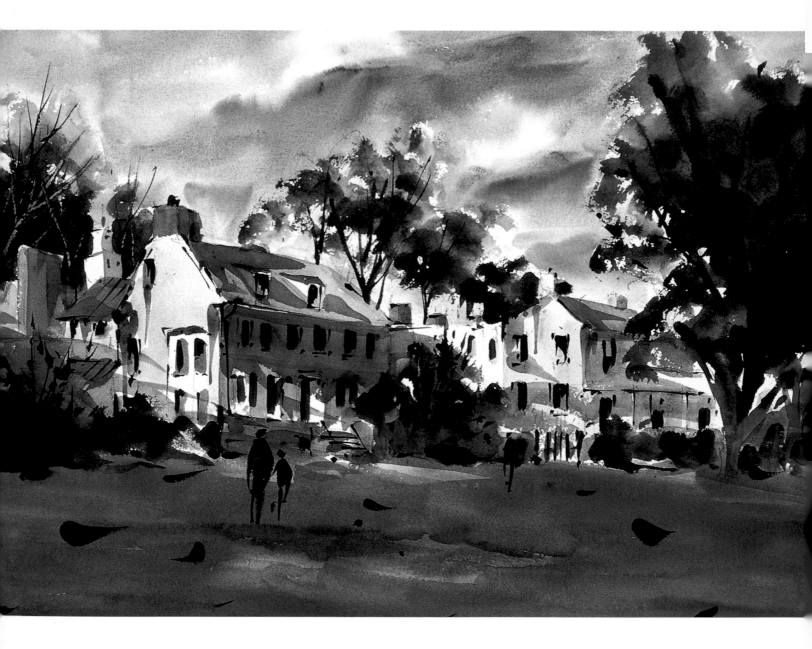

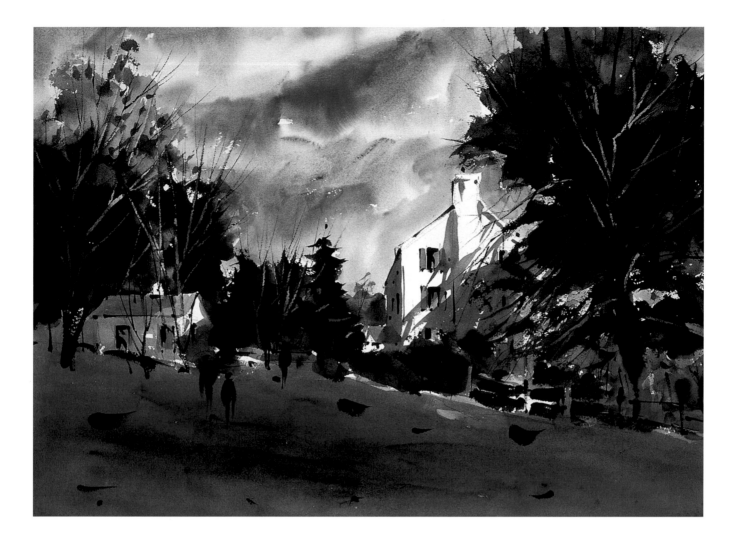

fall in delaware #2
22 x 30"

The two paintings pictured were done in late afternoon in New Castle, Delaware, at the end of the fall season. In order to bring out and emphasize the white buildings, I made my colors very strong. I used the complete value scale from light to dark in these two pictures. The long shadows are on the cool side with just a hint of warmth. I gave the sky a little action to help create a mood. This range of fall colors and values are difficult to do. You may tend to go toward winter or spring. If you are not sure in what direction you are going, make a color value sketch to keep you from making too many mistakes. I can say, generally, that when painting in the fall, I favor the warm side of my palette, using a few cool colors as complements.

my favorite barn
22 x 30"

I like the shapes of this barn and have painted it in all four seasons from different perspectives. This painting was done on a bright day in late winter. The placement of the barn in full sunlight was critical for the composition. You can see that more than half of the painting is snow. I wanted to get a lonely, desolate feeling. This painting was composed with one line.

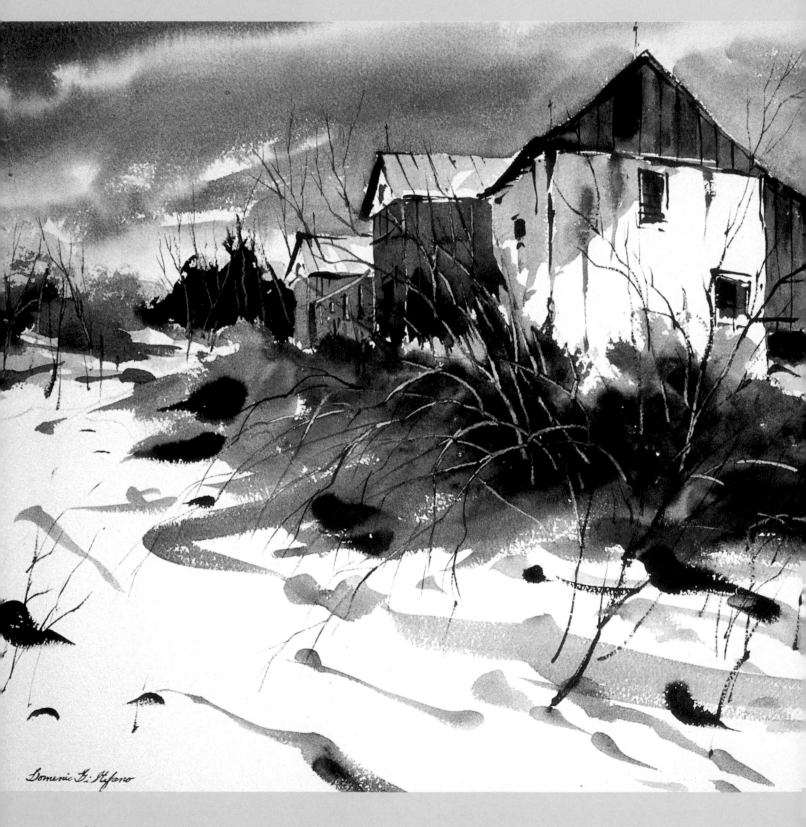

Domenic G. Stefano

painting
the Beautiful Bleakness of
winter

I HAVE PAINTED IN EVERY KIND OF WEATHER CONDITION, WITH a few exceptions—hurricanes for one, blizzards for another. While most outdoor experiences can be classified as pleasurable, the extreme cold of winter manages at times to put my sanity to the test.

But I'm not the only painter who has ever braved the elements to get that elusive, satisfying painting. Many of us up here in the northern climes have taken to the streets, the woods, the seashore to translate with paint the punishing blows of nature's freezing jabs and uppercuts that she has unleashed upon our mere mortal extremities.

Many people of my acquaintance have wondered why I don't photograph my scenes of winter, for it would be easy enough to spend a fraction of my time outdoors firing off roll after roll of film to then convert, in the

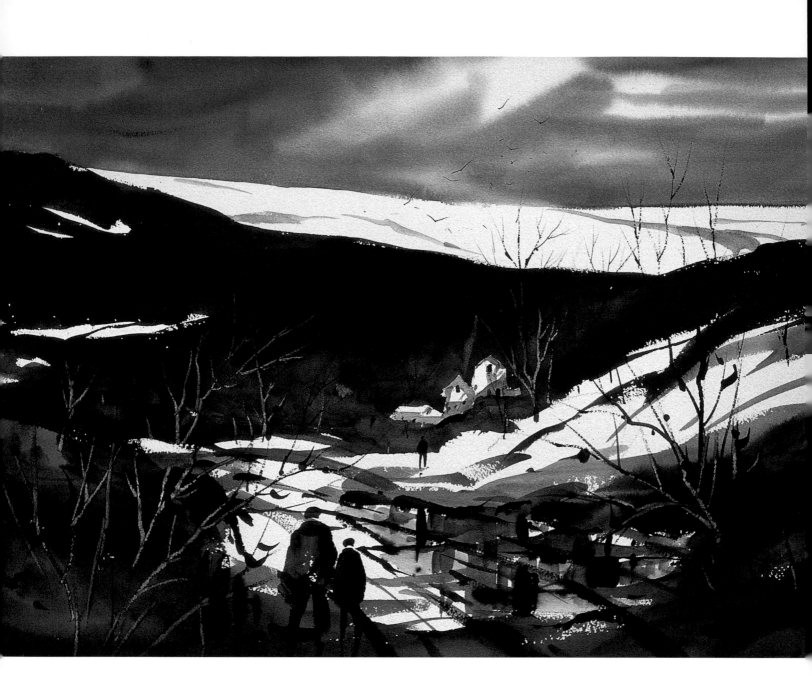

winter walk

22 x 30"

A warm painting done on a very cold day. As I painted it I could feel a storm coming, so I knew I could not waste any time. This contributed to my using stronger and darker values on the warm side. I painted this picture, as I normally do, from dark to light.

The colors that I used were Burnt Umber, siennas and a touch of Indigo Blue for my darks. The white of the paper formed the shapes of the snow. The sky had to have some movement to complement the rest of the painting, and this gave it a dramatic feeling.

warmth of my studio, into full sheet watercolors. Is it crazy, then, for me to opt instead to actually be there in difficult painting conditions? The answer, I believe, can be found in my paintings which bear a look, I've been told, that's much more spontaneous than any done completely from photographs.

Painting outside in the winter months *is* tough, but I have learned, as best as I can, how to handle the elements. I dress for warmth but yet not too bundled up. My gloves have had half of the fingers removed, thus warming most of my hand but still leaving me mobility with the brush; my feet are warmed with an extra layer of socks.

second snow
22 x 30"

I tried to keep this composition as simple as possible and, so, I created three single shapes. I wanted the trees to be massive; I did this by letting the trees go out of the top of the painting. By making the trees in the background a smaller mass, it gave me distance in perspective. This painting says "winter"; it's a medley of greens and blues. I used the white of the paper for the snow.

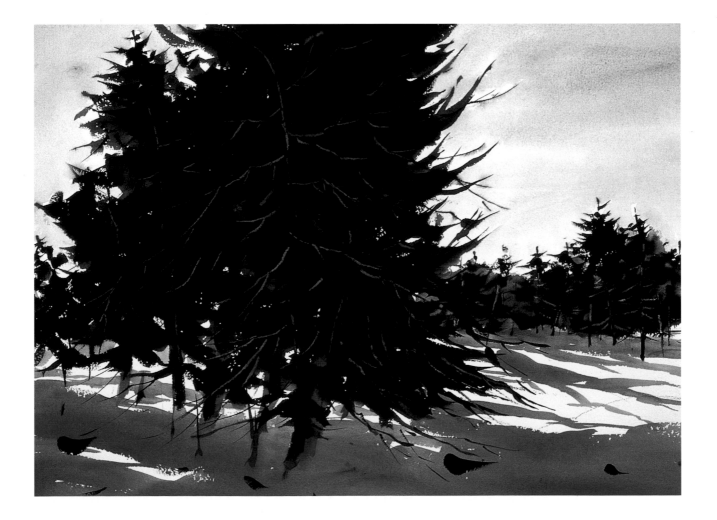

solitude

22 x 30"

A very cold January day with an exciting dramatic sky and deep shadows. This kind of day is rare. I had to paint quickly because the light was changing rapidly. As you can see, the sky sets the mood for the painting. I normally put my skies in last. This painting shows that you do not need snow to create a cold winter scene. The white of the building is the point of interest.

There are colleagues of mine who have outfitted their vehicles so that they can paint inside. I have never been comfortable in that kind of setting, preferring to be outside. Of course, a thermos filled with hot coffee makes a mighty good companion.

An important factor to painting outdoors is that when I arrive at the scene, I could begin painting immediately since some days earlier I had already picked out the painting site, even having made some preliminary sketches. I try to paint between ten in the morning and three in the afternoon, a period that I find the warmest in the day, when my paper doesn't get as damp.

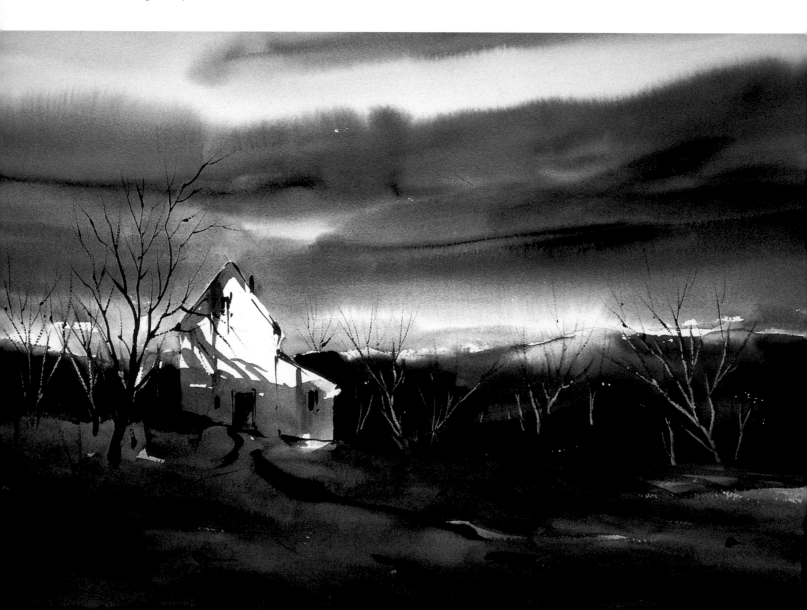

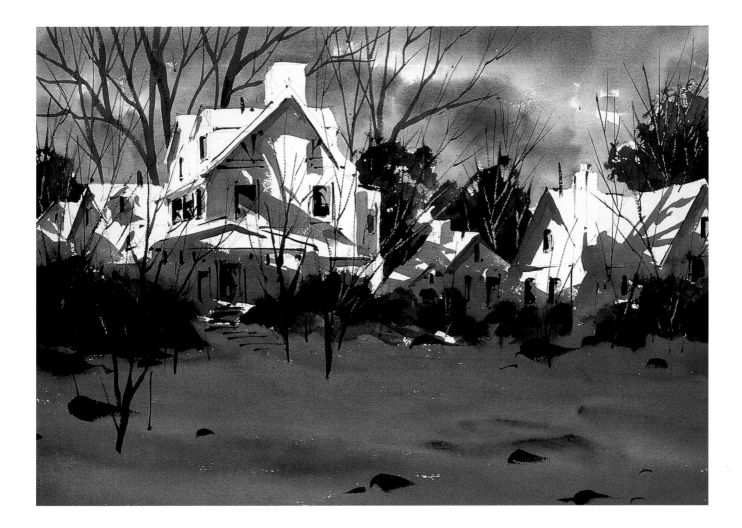

**house across
the street**
22 x 30"

Painted from my studio window in Havertown, Pennsylvania, I like the shapes of this house and have used them in other compositions. I've wanted to do a portrait of this house for many years and finally saw this composition the day after a snow storm. I did the painting in early morning when the sun was just hitting the upper portion of the buildings, creating some beautiful shadows. The colors I used are on the cold side, done in blues with a touch of warmth given to the trees in the background. This is a one-line composition.

As for the painting itself, one of the challenges of winter painting is using the white paper for the design of my snow shapes. For this reason, I paint my darks in first to make sure that my white shapes come forward. I use all my colors because winter comes in warm and cold values. I find that my color values are either gray lavender or brown. I sometimes have to tone my whites down because of cloud cover.

At times, in extremely cold days, I have added a few drops of alcohol to my water to keep it from freezing, but there were a few times when I found that my paint was freezing on my paper. I knew then that it was time to pack up, go home and finish the piece in my studio.

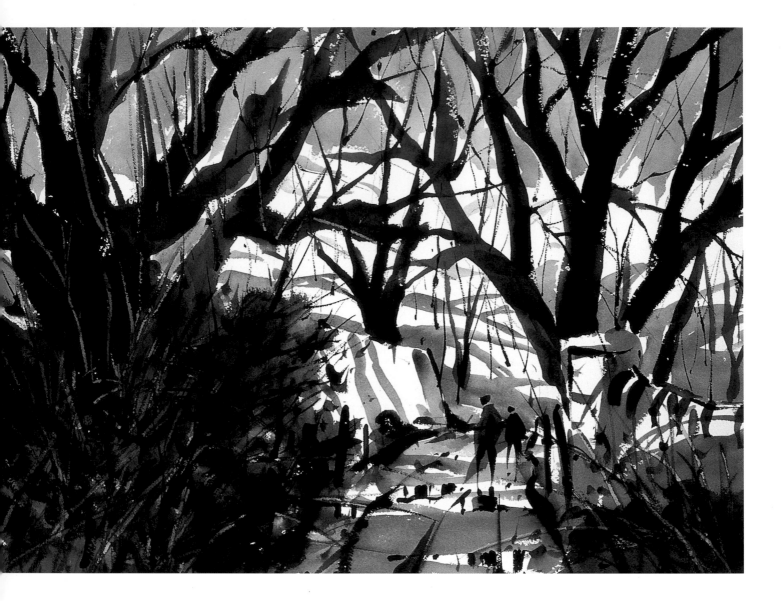

winter trees

22 x 30"

I painted this group of trees from the middle of the road, painting while on my knees and resting on a kneeling pad. The snow in the road thawed and I soon found myself kneeling in the mud! In this painting, I created a dark feeling against a light background. The bark of the trees is very, very dark because it was wet. This painting was hard to compose because I had to eliminate some trees to create distance between the branches. As you can see, the design of the branches created snow patterns which are the white of the paper. I painted this picture in late winter. In another week, as the weather got warmer, the color and feeling of this composition would have changed.

a step-by-step demonstration of a winter scene

PALETTE

Cerulean Blue

Burnt Sienna

Indanthrene Blue

Indigo Blue

Alizarin Crimson
(just a touch)

Raw Sienna
(just a touch)

The whites are the white of the paper

STEP *I started this painting with just enough pencil lines to guide me through my composition. I designed the house to be in proportion with the mountains and to give me distance.*

For this painting of winter, I favored the cold blues with a touch of warmth to complement the blues. These are the colors I used.

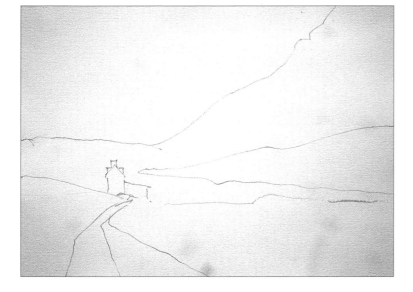

STEP *I put the dark values in first, making sure that I saved the white of my paper for the snow shapes or patterns. Paint of other values will form the shape of the snow. Shapes make shapes.*

I save the white of my paper for the snow shapes or patterns.

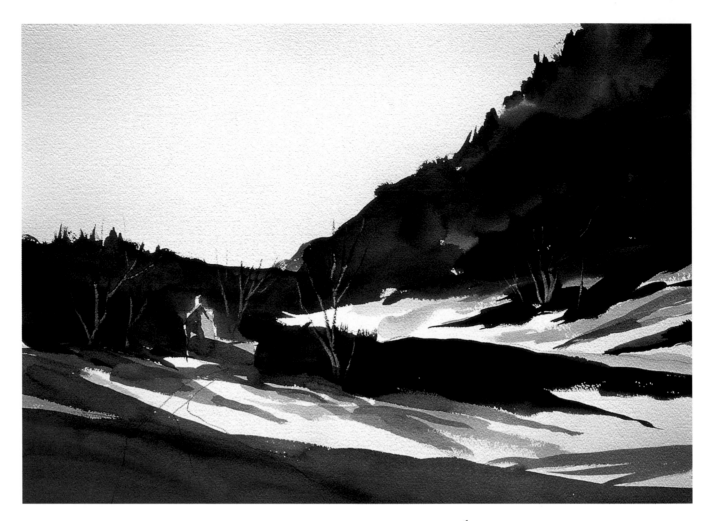

*I wanted the painting
to have a cold look so
I favored the blue.*

STEP **3** *I used a slight shadow
on the house and a
shadow in the fore-
ground to help me
create the shapes of the*
snow. There is just a touch of warmth in
the snow. I felt I wanted the painting to
have a cold look so I favored the blue.

STEP 4

I put a touch of warmth in the sky to complement the warmth in the snow. The sky still has a cold look. I felt the sky needed a dark note so I added some birds. The figures give me an illusion of distance and help put the mountains in proper scale. This painting has three shapes: the sky, the middle ground, the foreground.

painting of winter
22 x 30"

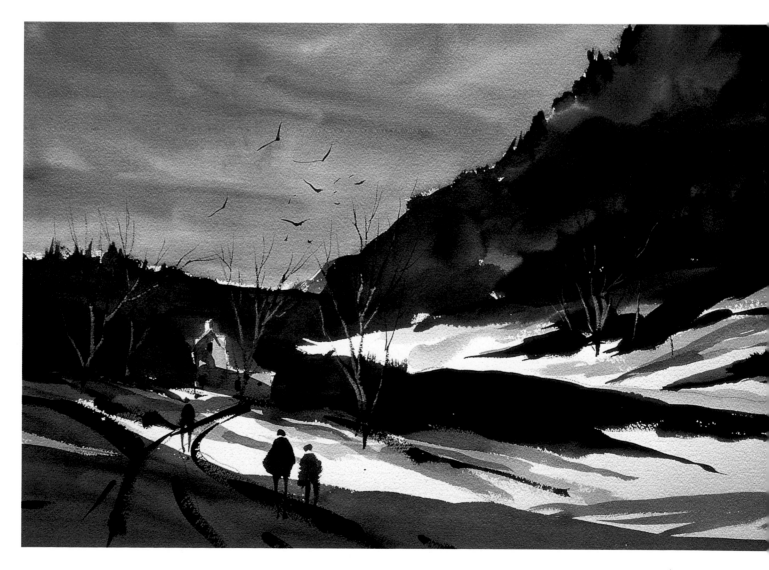

baltimore inner harbor
22 x 30"

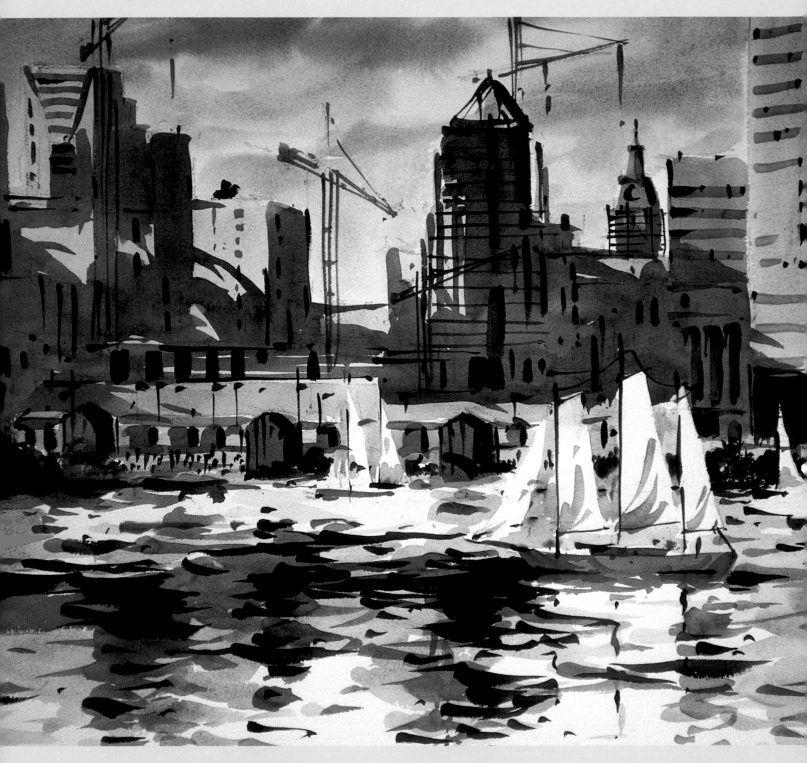

11

reflections

*R*EFLECTIONS ARE A VERY IMPORTANT PART OF YOUR composition. They are basically a mirror image of the subject matter you are painting. I have trained myself to put the reflections in at the same time that I paint my subject. This way there is no room for error. Invariably, my students will say: "I'll put them in later." Know what? Later is too late.

I make an indication of my reflections with a few lines when I sketch my composition. Sometimes I feel that the reflections I have indicated in my drawing need to be adjusted in order to enhance my painting. I may need more or I may need less. I do whatever will improve my composition. I don't let the truth spoil a good painting. Your distance from your subject will determine the amount of reflections you need. The closer you are to the subject, the more you will see. Your reflections will be smaller from a distance.

Reflections in mirrors and windows are reversed so be sure to study them carefully before painting them. The color values will also change in the window reflections. Reflections in water may vary depending on the action in the water and whether the day is windy or calm.

After talking with my students I find that they don't see the reflections in the water. I try to get across to them that they have to look and see. The reflections certainly are there. You just have to find them. Here are some examples of how I handle reflections using various subject matter.

gloucester street
22 x 30"

The size of the puddle will determine the size of the reflected image. You can make the puddle any size you want in order to help your composition. In this composition, the puddle did not exist. I put it in to create more interest in my painting.

building puddles

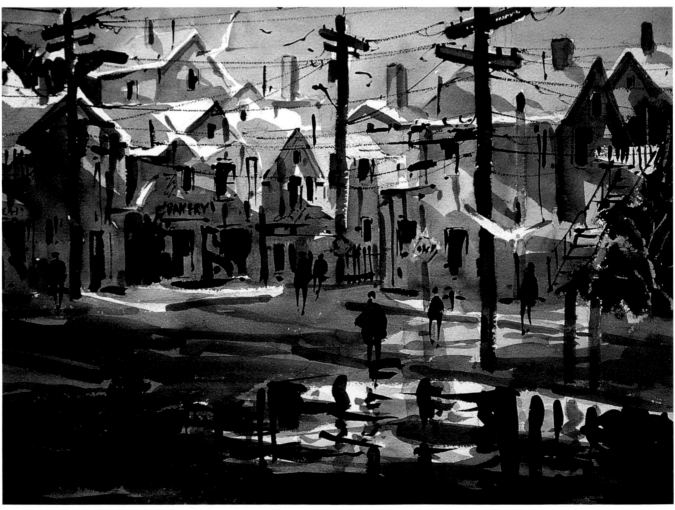

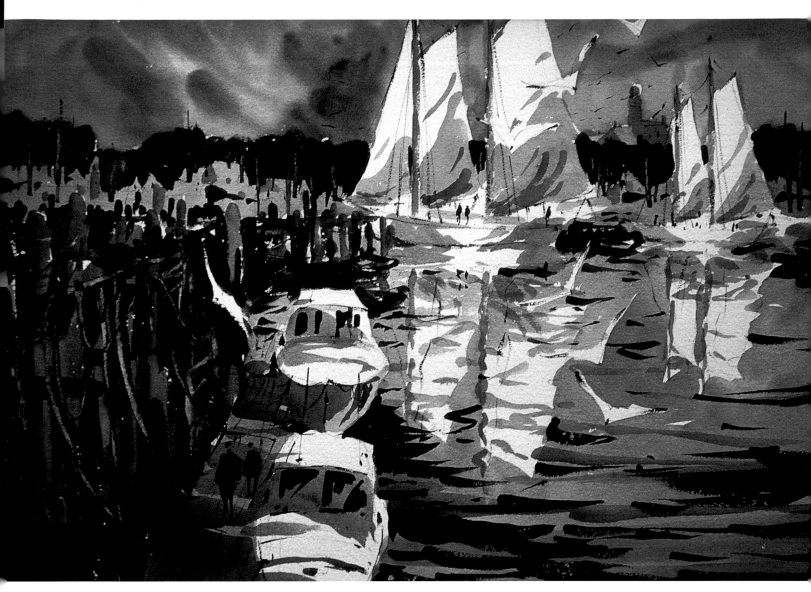

inner harbor

22 x 30"

When painting reflections of sails,
keep in mind the shape of the
sails and the distance they are
from you. I painted around the
white of my paper to leave all
these sails white and to give my
painting a dramatic feeling. This
also gives the painting a feeling of
action and movement. The white
of the reflections in the painting is
also the white of the paper.

gloucester, ma

22 x 30"

Boats give beauty and action to
reflections. Keep studying the
reflections until you are familiar
with their shapes and colors.
Boat reflections will sometimes
have an abstract feeling.
Sometimes they are almost a
painting in and of themselves.

boat reflection

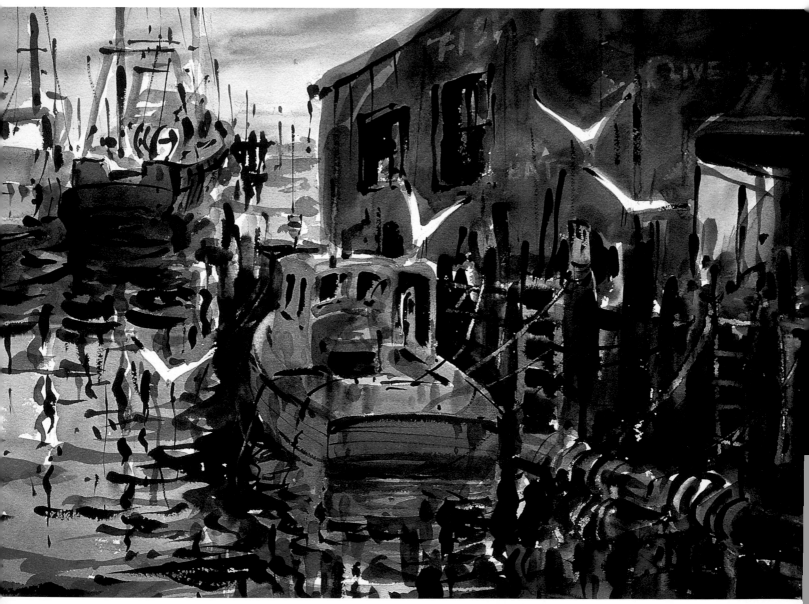

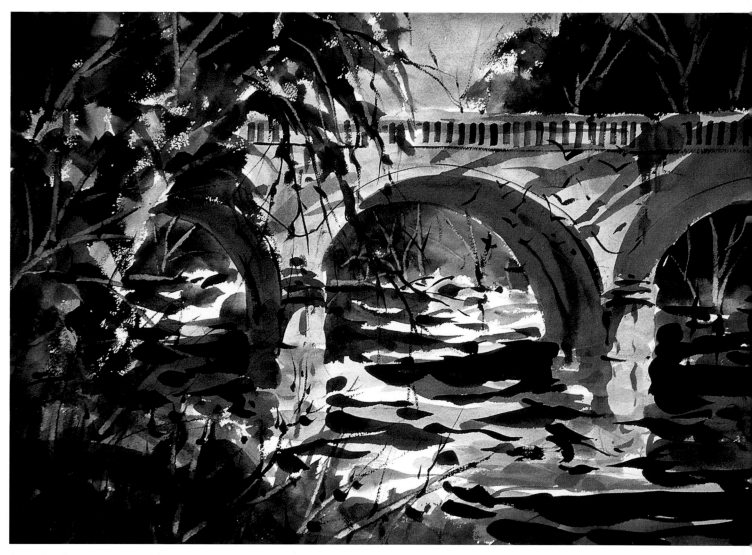

bridge reflection

brandywine river

22 x 30"

This painting was done at the
Brandywine River in late summer.
I focused on the action of the
river. These types of reflections
require a lot of study. I sometimes
call this a lost-and- found action
because the reflections can be
lost with the movement of the
water. The reflections are more
apparent on a calm day and
easily lost when the water is
more active.

waiting for the crew, gloucester, ma
22 x 30"

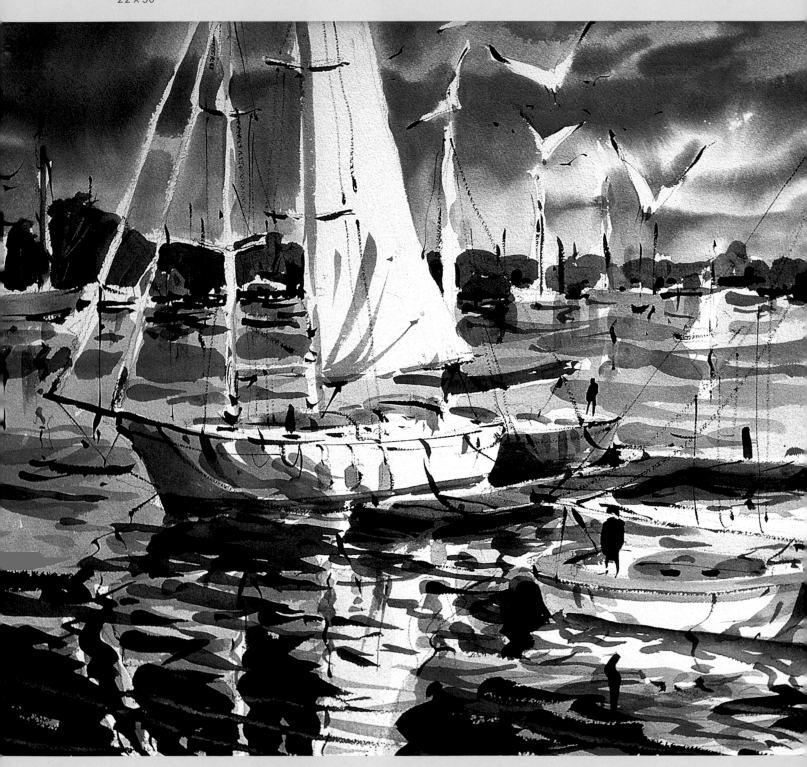

12

boats

*I*F YOU'RE TO BE A MARINE PAINTER, YOU HAVE TO FACE THE fact that you won't always be only painting objects of nature: rocks, grass, trees, and, of course, the sea in all its moods. Other important elements that you'll have to contend with in marine painting are man-made. They are the docks and buildings in the harbor, and boats of all descriptions.

Adding a boat to your composition makes for a fascinating presentation. You can paint the boat in its entirety or merely sections of it. It's up to you to decide which boat shape is best for your composition and whether to portray the bow, stern or side view. I try to capture each boat's character and proportions and the conditions that will most benefit my composition. For instance, a painting done at low tide will have a different character and look than one done at high tide. Spend

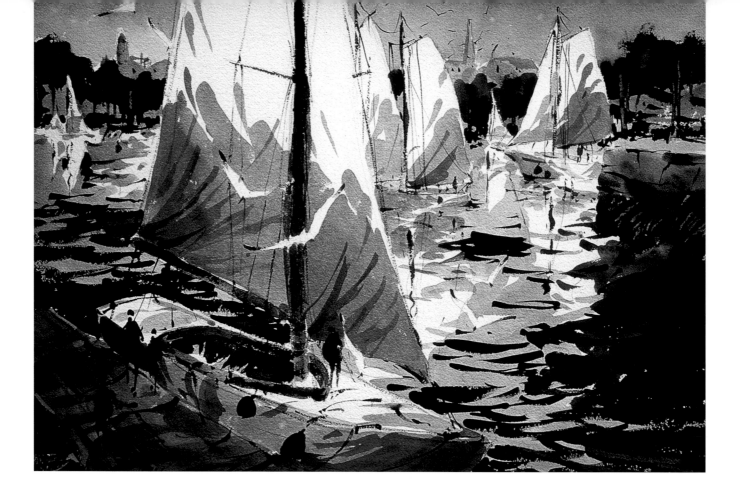

sails are up
22 x 30"

This painting was done on a gray day after a rain storm. I wanted to feature the boat in the foreground but realized that something was missing—the sails. So I drew on my knowledge of boats and put the sails up. You will notice that the sails take up most of this composition. The smaller sails in the background give me distance and proportion. I do not use Payne's Gray or any other tubed grays. I'd rather rely on my knowledge of color to mix my own grays. The grays in this painting are cold, made by mixing my primary red, yellow and blue to make gray (see Chapter 3, My Color Family) and then adding in some more blue to cool the mixture.

some time observing boats and get a feel for them before you start painting them. Study carefully the scads of details aboard each boat, especially the function of the rigging. It is such a temptation to just paint a bunch of lines all over the boat. But that will not do; you have to get to know it. Look at each line of the rigging and see where it starts and ends because each line has its own purpose. Pay attention to the boat's anatomy because people who know boats will ridicule an inaccurate rendering.

inner harbor
22 x 30"

This painting of the Inner Harbor, Gloucester, Mass., was done after a fog had lifted. The scant appearance of the sun warmed up the scene a bit. I captured this effect by mixing red, yellow and blue to make gray, and then warmed it with Burnt Umber. I was searching for a composition when I saw these beautiful sails coming around the docks. I had to sketch quickly to get my composition and record the moment or it would have been too late; the boats would have been gone. I wasn't concerned about the other boats in the composition. They were tied to the docks so I knew they would not be moving.

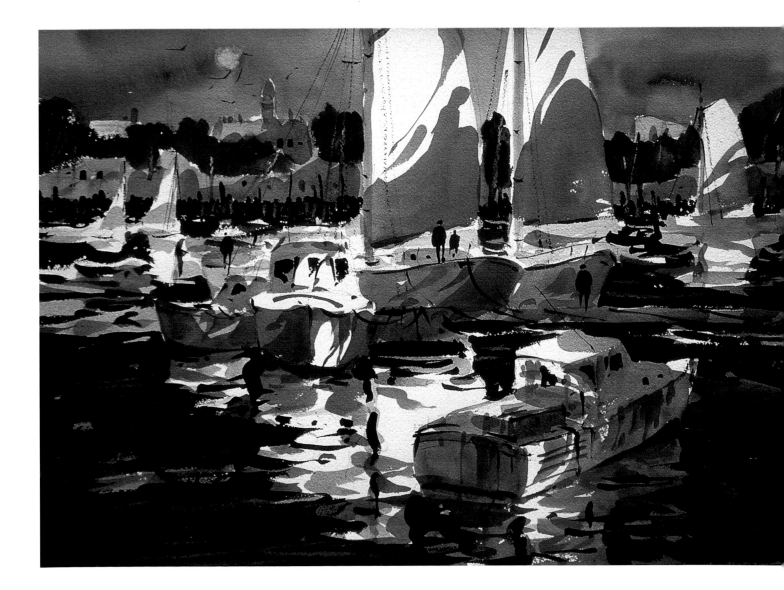

Reflections are ultra important because they are the ingredients you have to use properly to make your boat sit in the water and not on top of it (see Chapter 11 on painting reflections). Another bit of advice, don't forget proportion and perspective, elements of drawing that can't be denied. When I paint a boat, it is part of my composition and, whether tied to the dock or out at sea, it is used to tell a story.

Keep in mind that boats are like a piece of music, each has its own rhythm.

schooner races
22 x 30"

Every year, the highlight of my summer stay in Rockport, MA, is the schooner races in nearby Gloucester. These races are beautiful to see, but an agonizing challenge to paint. As the schooners pass the bystanders on shore and boats, we can hear the crews hollering "heave-ho, heave-ho" and the first thing we know, the sails are up. It's all very exciting, and I find myself working as fast as the boats' crews are as they speedily sail by. The action goes by so quickly that I have to be ready instantly for the next one. This composition was done on a very windy day, great for sailing, hectic for painting.

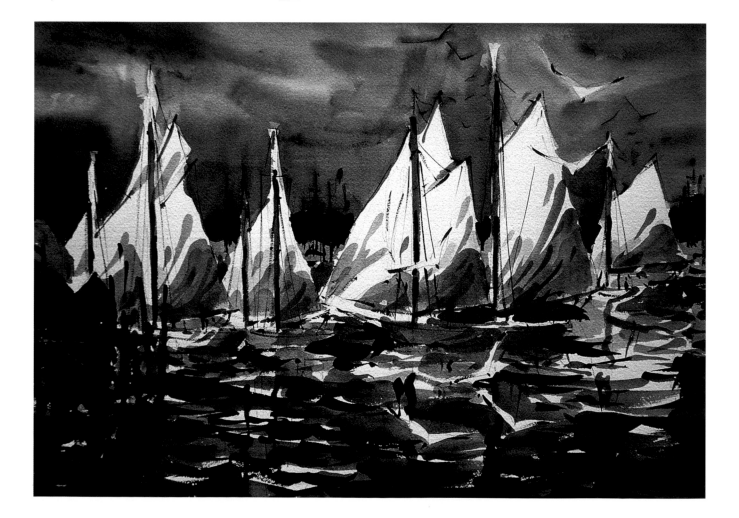

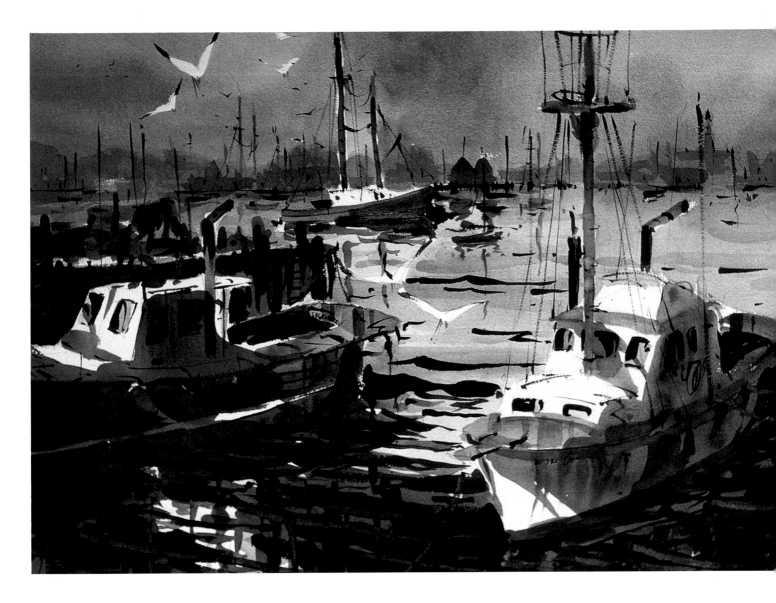

morning light
22 x 30"

I'm amazed that this painting was ever completed. First, the boat that appears on the right of the painting left the scene while I was painting it. And as if that wasn't bad enough, a torrential rainfall immediately followed. I came back the next day hoping I could finish my painting. I have to say that I wasn't too optimistic. But it all turned out to be a blessing in disguise, because the sun was out, creating the dramatic feeling of light and shadows that you see in the painting. I was happy with this work and, apparently, others were, too. The painting won an award in the American Watercolor Society annual show.

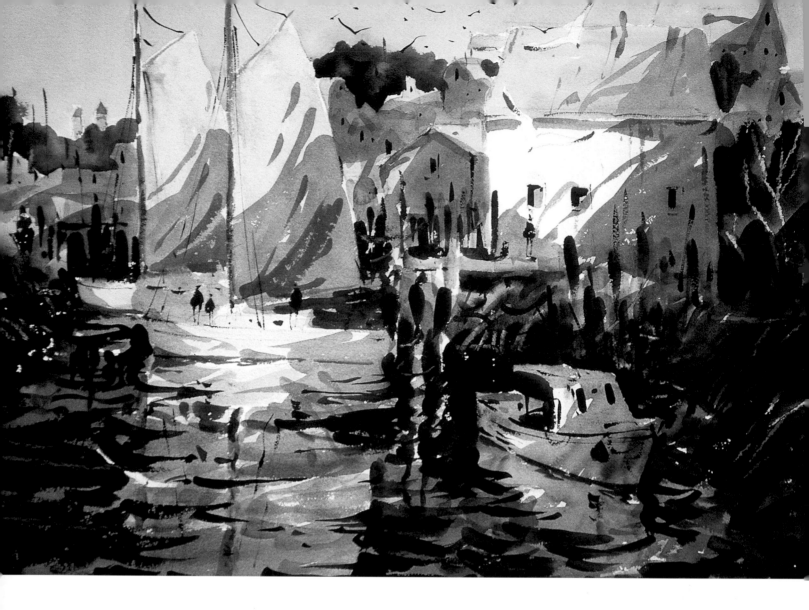

late afternoon
22 x 30"

I was interested in the play of the late afternoon light on the sails and on the building. The boats in the lower portion of this composition are in shadow, which helped to give the painting a dramatic look. The combination of light and shadows that's seen in this composition does not always happen. You have to search for it. I enjoyed doing this painting; I was happy with the result.

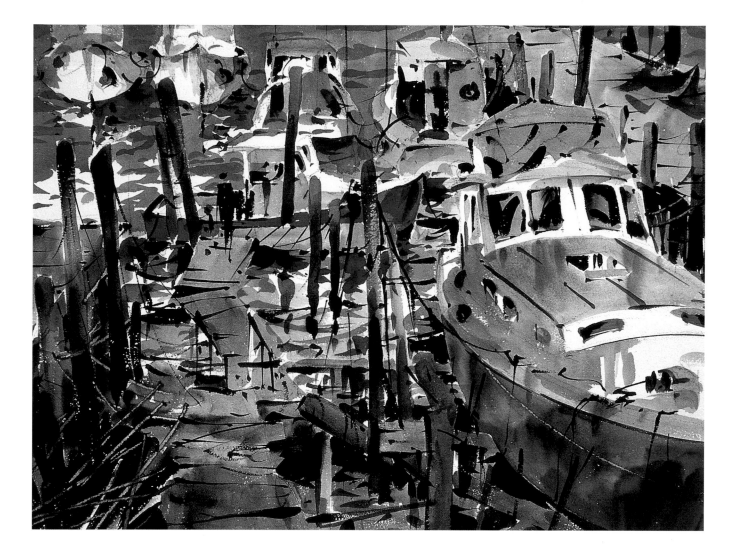

all tied up
22 x 30"

This painting was done from a second-floor window of a building where a friend of mine builds boats. I went in to say "hello," looked out of the window, and found a composition begging to be painted. I rushed home to get my painting gear; I did not want to lose this opportunity. Everything was just right. The design and patterns of the floating dock caught my eye, as did the boat being repaired on the right. The boats in the background gave me a sense of looking down. I liked the texture of the patina on the floating dock and on the pilings; it added much to the painting. Looking down on the scene created a high horizon line, and, as you can see, presented me with a perspective challenge.

just waiting

22 x 30"

There is a great contrast between the subject mat-
ter in this painting. The white of the paper and the
huge pilings were a great help to my composition.

You've got to keep in mind that since fog can
burn off at any given moment, you have to work
a little faster to rivet that great scene to paper.

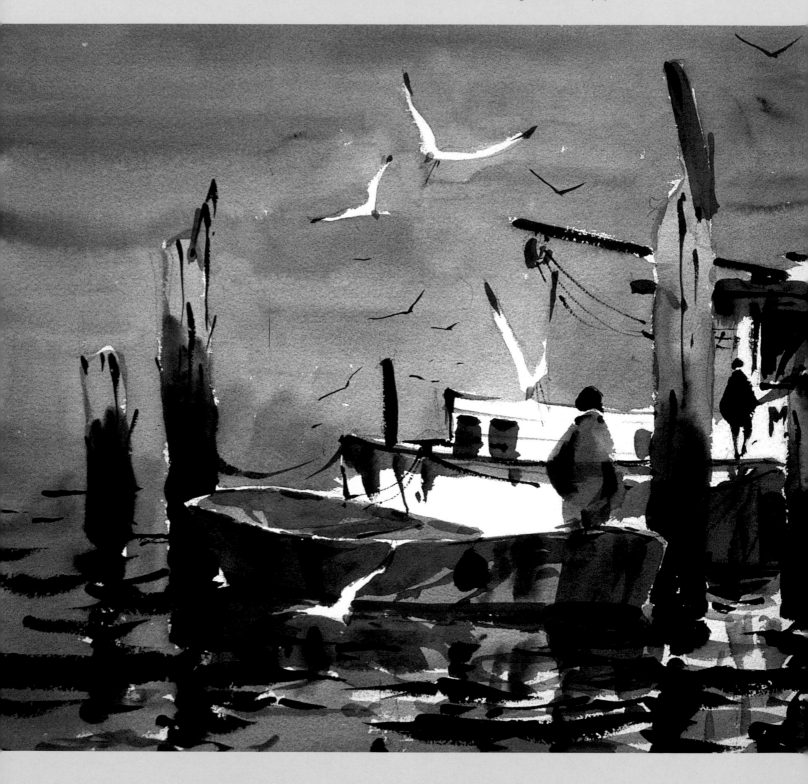

13

fog
In Various values

I AM SURE THAT EVERY ONE OF YOU WHO DRIVES A CAR HAS been caught in fog at one time or another. Don't you find yourself moving your head closer to the windshield and squinting in an effort to defog the scene before you? It's far from a pleasant experience.

For the seaman, especially one sailing a small radar-less vessel, a fog at sea is frightening. It is, without a doubt, a nerve-wracking experience.

For the landscape painter, safe and sound with paints, paper and brushes, a fog presents an exciting challenge. The possibility for a successful experience is exhilarating.

Fog paintings seem to have a general appeal. Perhaps it's due to the well-lit, dry and cozy environment in which people find themselves as they view the dark, damp and cold-looking artistic renditions of a world in mist. For them, the experience is comforting.

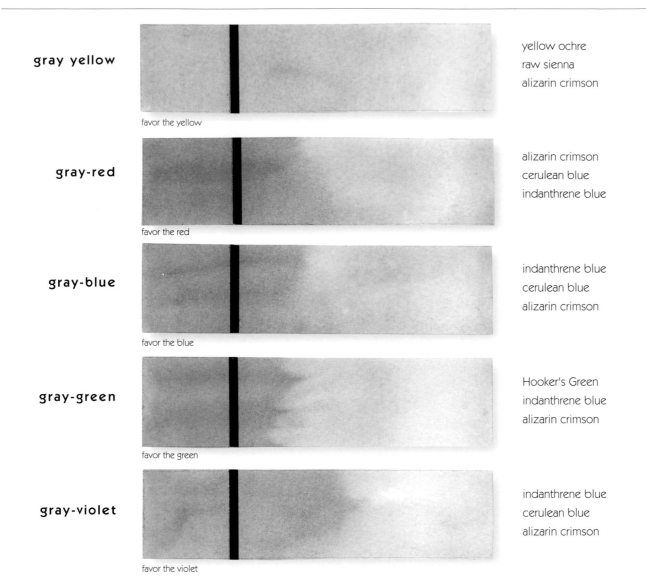

gray yellow — favor the yellow

yellow ochre
raw sienna
alizarin crimson

gray-red — favor the red

alizarin crimson
cerulean blue
indanthrene blue

gray-blue — favor the blue

indanthrene blue
cerulean blue
alizarin crimson

gray-green — favor the green

Hooker's Green
indanthrene blue
alizarin crimson

gray-violet — favor the violet

indanthrene blue
cerulean blue
alizarin crimson

Figure 1.

FOG COLOR BREAKDOWNS

The five colors in this chart are the ones that I use for all paintings of fog. You can see that they are all chromatically reduced versions of their brighter mass tone colors (as they come from the tube). These colors have been created in the following manner:

1st band	Gray-yellow, favoring the yellow: Yellow Ochre, Raw Sienna, Alizarin Crimson
2nd band	Gray-red, favoring the red: Alizarin Crimson, Cerulean Blue, Indanthrene Blue
3rd band	Gray-blue, favoring the blue: Indanthrene Blue, Cerulean Blue, Alizarin Crimson
4th band	Gray-green, favoring the green: Hooker's Green, Indanthrene Blue, Alizarin Crimson
5th band	Gray-violet, favoring the violet: Indanthrene Blue, Cerulean Blue, Alizarin Crimson

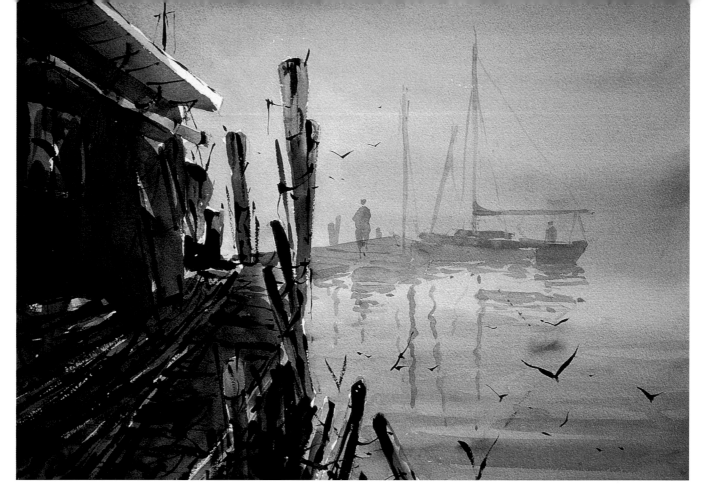

Figure 2.

smith's cove
22 x 30"

Done in early morning, the composition was in place for me: the fog, which is apparent, and the foghorn, which provided me with an important atmospheric element in my painting of the scene. While it's obvious that you can't hear the foghorn, I painted the scene with the hopes that through my interpretation, the sounds of the foghorn would be subliminally there for you. I painted the fog using warm tones on the gray-violet side. I did this with a grayed wash of Indanthrene Blue and a touch of Alizarin Crimson The paper was already damp with the moisture of the fog so I had to come in with a fully loaded brush of color. I used more pigment than I usually do.

If you are planning to paint a landscape in foggy conditions, the first concept you should dismiss is that fog is plain gray. That's not true; a painting of fog can have exciting color values. To further explain, fog can be either warm or cold. Why is knowing this so vital? When the sun is trying to burn off the fog, the values will be warm. On a gray day, when the fog is socked in, you will find cold values. Understanding this will help you determine the color value that you will use to picture fog in your painting. Refer to **Figure 1**; it will help you to make your choice easier.

a three-step analysis of a fog painting

The three-step breakdown that you see here graphically shows an analysis of my fog painting, *Smith's Cove*, in **Figure 2.**

STEP

1

The foreground shown as sharp and in focus.

I can't tell you how much of each color to use. You have to try it yourself until you get the value you want. Furthermore, there's no reason why you can't use your own color palette to make various grays for fog. Experiment, experiment, experiment until you can see what you can do with your palette. The combinations are unlimited, even with my limited palette. The result you are looking for is to paint beautiful fog values.

The painting of fog is not solely a matter of the color you choose to use. A relevant factor has to deal with how you apply your paint. Being aware of this will show you that the foreground colors have to be put in sharply and in focus. The middle ground will be out of focus, or merely a silhouette of shapes. Finally, in the background, you will have to choose a color value that works well with the rest of the painting. **Figure 2,** *Smith's Cove,* is a good example of this three-stage paint application.

2
STEP

In the middle ground, we see the silhouette.

3
STEP

The background is color value that is relevant to the color scheme of the painting.

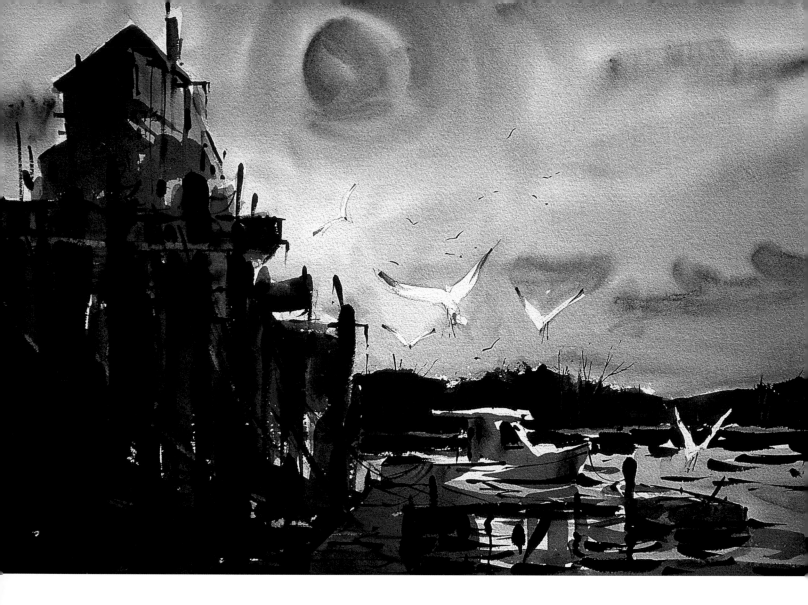

lifting fog

22 x 30"

I certainly was in the right place
at the right time for this painting.
From my perch on a floating
dock, I happened to be looking
up when I saw a great contrast
of dark foreground against a
gray-yellow fog. The sun was
just starting to burn off the fog.
Fortunately, the fog stayed
around long enough for me
to finish my painting.

north channel

22 x 30"

I painted this landscape in
Gloucester, Massachusetts, one
of my favorite sources for inspira-
tion. I captured this scene right
after the rain had stopped. The
fog rolled in and created a heavy
mist. But there was another bank
of fog that was following this
one which meant that I had to
work furiously. It was like this all
day with the fog coming in and
going out. The tones or values
used in this painting were on
the gray-green side, made by
graying Hooker's Green with
complements.

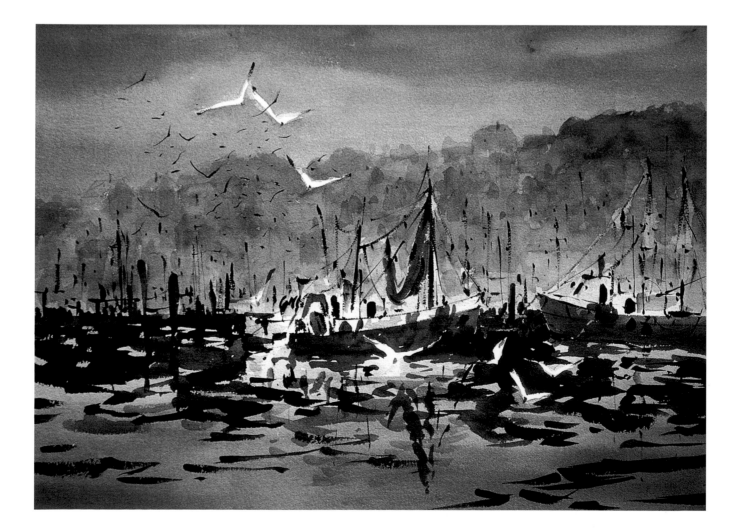

morning glow

22 x 30"

This type of painting is a happening because the light and shadows change so rapidly. You have to invent the shapes of the shadows to create the light that you need. This takes practice, observation and intestinal fortitude. You have to be at the right place at the right time to capture this type of composition. You must move quickly because the composition can be lost in a matter of minutes.

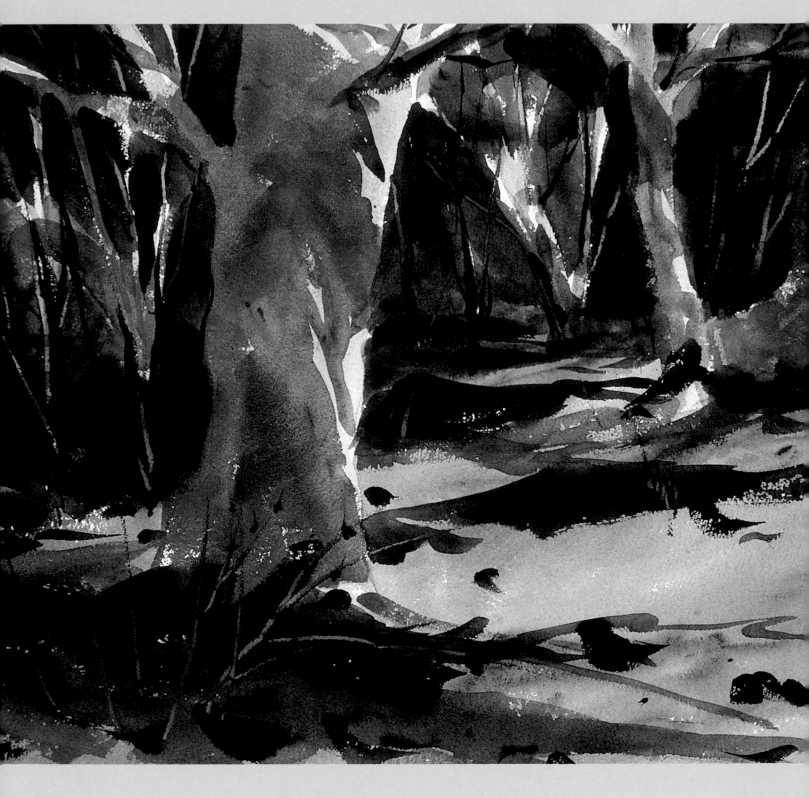

light & shadows

WHEREVER THERE'S LIGHT THERE WILL BE SHADOWS. THESE two elements of tone are all important to painting, especially outdoors where you are relying totally on nature's illumination. I'm sure you all realize that when painting outdoors, you are faced with an ever-changing sun. I must caution you, therefore, to be careful of the shapes that are created by the source of light; they can make or break a painting.

When you first decide upon the light and shadows that you will use for your painting, make sure you are happy with that decision; you have to be satisfied with the way the light and dark patterns look on your paper. The movement of the sun will surely change the shapes of the light and the shadows. You can't let this natural phenomenon throw you. Instead, you have to focus on the work you did on your initial impression of the

view from the third floor

22 x 30"

This painting was done from the third floor of my mother's home in Providence, Rhode Island. I had seen this composition for a number of years but just could not put the puzzle together. One day, everything fell into place. Because I had been studying it for sometime, the painting moved right along. It was important to hold the light as the shadows moved rapidly, and I did not want to lose the light-and-shadows combination. Remember, shapes make shapes. I was intrigued by looking down and seeing the shapes of the houses in the distance. The light and shadows created beautiful shapes. The white of the paper is very important to me and, of course, to all watercolorists. Notice how the white on the house created the light I was looking for.

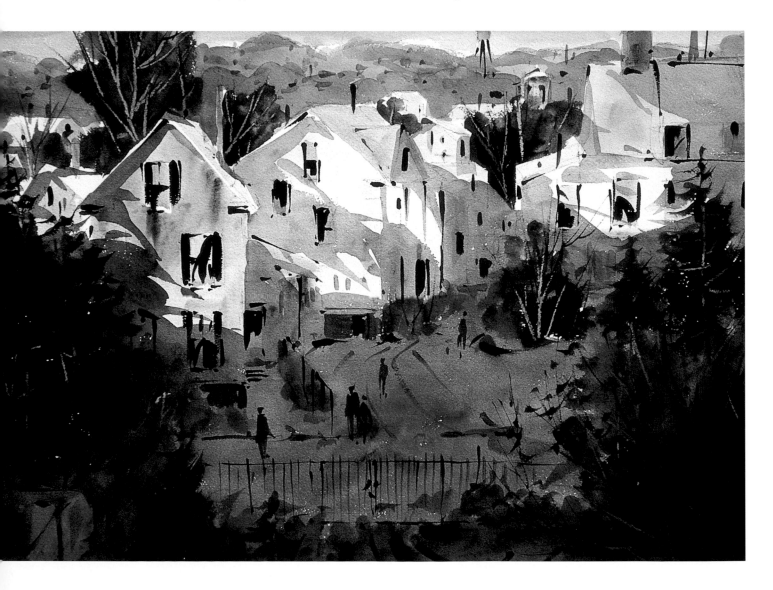

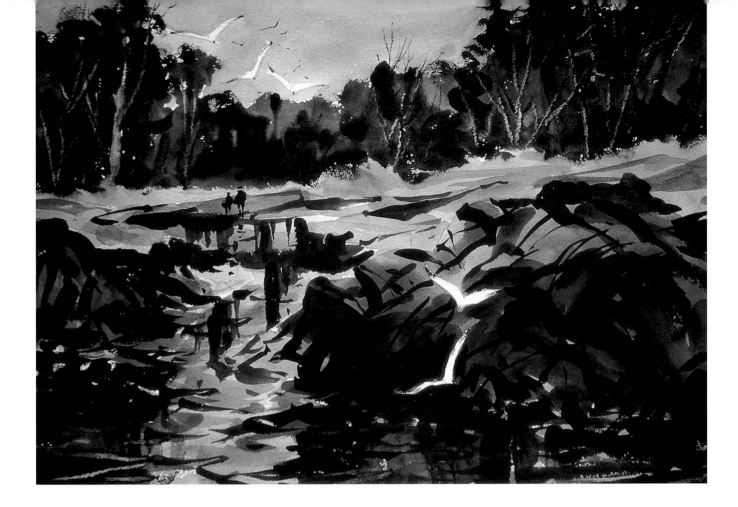

ipswich river
22 x 30"

The light and dark plains of this composition intrigued me. It gave me an abstract impression. The tide was out when I started this composition, and I had to be careful that I did not lose my first impression as the tide came in. The rocks on either side were dark values and by adding shadows on top of the rocks, I created abstract shapes which included the reflections in the water. The trees in the background were also dark values which gave me distance and helped to create the light passage in the middle ground. The two white seagulls in the foreground helped to bring the painting forward. I often use seagulls to create action in my paintings.

sunlight. Since, during the course of your painting outing, the sun's subsequent movements are going to change the light and shadows, this may tempt you to change your composition in mid-stream. Resist any attempt to change. You have to reconcile yourself with the unalterable fact that these movements of the sun will go on and on throughout the day.

What if you find that the light and shadows of your first placement are not right for your composition? In that case, you need to learn to invent the light and shadows that you need. Make the change, early in your painting, be satisfied, and then sink or swim with that decision.

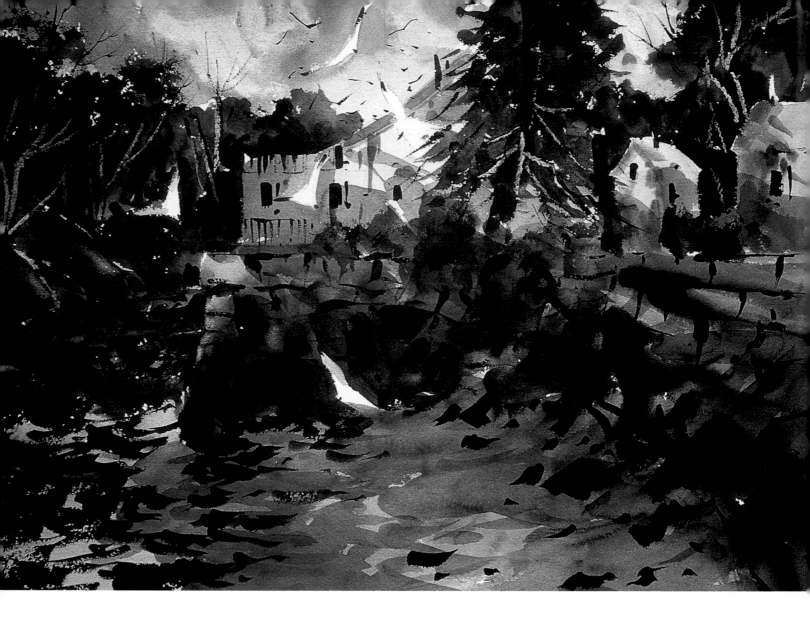

town landing, ipswich, ma

22 x 30"

I frequently paint on the Town Landing in picturesque Ipswich, a town about fifteen miles from Cape Ann. I seem to find never-ending compositions there. This is an afternoon painting where I had sharp light and shadows. I used seagulls to bring my painting forward. I used the trees as a dark background around the houses to create the light and shadows. This is the type of painting where you must work fast so as not to lose the light and shadows. Try to keep your first impression in mind.

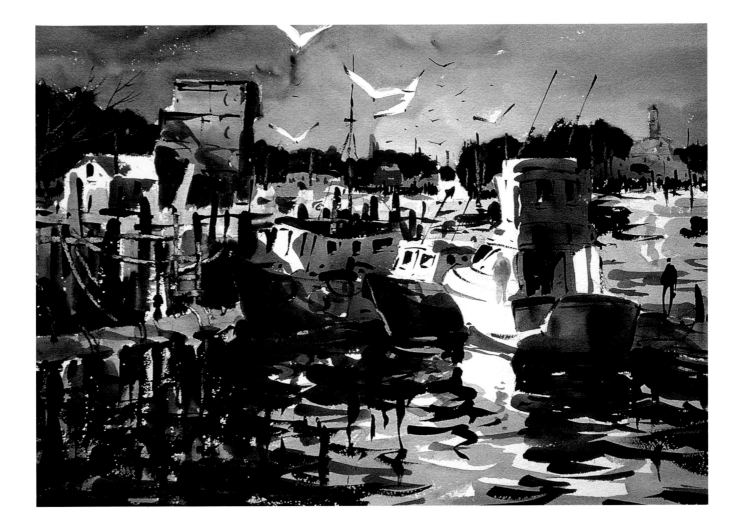

morning light
22 x 30"

When I first saw this composition, I felt that I needed a shape on the right-hand side. By dumb luck the boat on the right arrived and the problem was solved. The boat on the right acted as a stopper to keep my eye in the composition. This painting was done after a fog and has a warm glow. The whites in the painting are the white of my paper (this includes the seagulls). The whites were placed to complement the shadows. I purposely made the shadows a little stronger in this composition to create a dramatic effect of lights and darks.

Light and shadows have shapes and mass like the rest of your composition, and will help you to create your point of interest. When you're out for a walk or on location, make it a practice to observe the play of the light and shadows, put that in your memory bank, and use it at a later date.

a gloucester house
22 x 30"

This house is being restored. This painting was done before the restoration began. I was in Gloucester searching for a street scene when this composition jumped out at me. The building has unusual shapes and was a challenge to do. I put some action in the sky to complement the building. I had to be inventive when painting the shapes of the shadows. The dark shapes of the trees in the background helped to create the powerful light on the building. Again, to find a composition like this, you have to be at the right place at the right time.

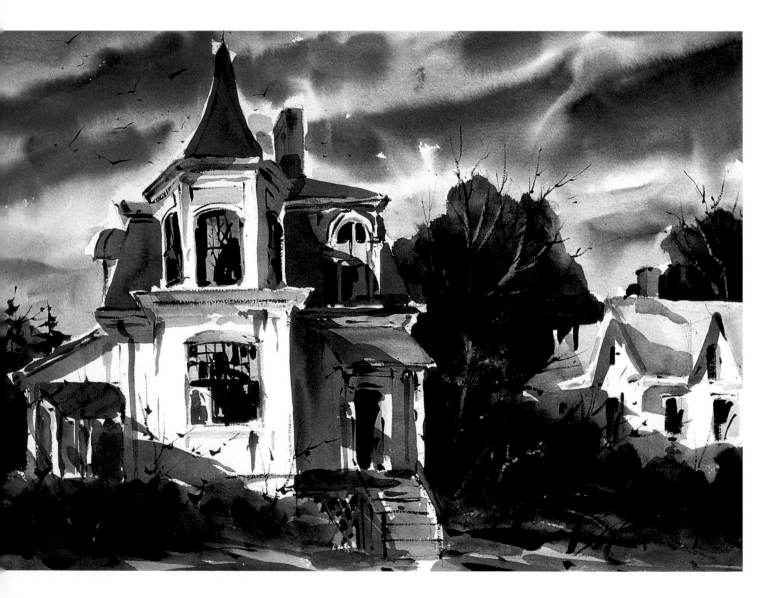

jersey pines

22 x 30"

I saw this composition when
visiting my daughter in northern
New Jersey. I had to play a
waiting game to capture the light
in the right place to produce the
warm glow. I had to be careful not
to make the lights too spotty. This
painting is basically all in shadow.
I used the lower portion of the tree
trunks to create this powerful com-
position. I am planning to do this
composition in the winter with
snow on the ground to see how
it compares with this painting.

15

final thoughts

FOURTEEN CHAPTERS. AND NOW WE COME TO THIS—THE END OF A thrilling journey. We've painted rocks and sea and grass and trees and clouds and fog and houses and barns. I say "we" since this has been a joint effort. Right from the start, your interest in watercolor was my prime motivation. Showing you how I do it, I hope, will now make your way with watercolor an easier medium of expression than it ever was before we met on these pages.

So, now, Chapter 15, time to say good-bye. I've had a marvelous time. I told you about the unlimited things that can be painted with my limited palette; and about my unorthodox way of painting. Of course it's not for everyone. I merely wanted you to understand that there is a definite margin of freedom for individual expression despite the discipline that's needed when painting a valid, plausible, interesting portrait of nature.

Here's an excellent shot of how I work at my "easel" on all fours. The Rockport dog dropped by to see what was going on. He didn't seem too excited to discover that everyone was merely watching another four-legged creature.

I am seen here answering a question from one of my students during a painting demonstration at my workshop in Rockport, MA. The friendly banter broke the tension that always accompanies the on-location painting of a landscape.

Photos by Barbara Ostrander

What I liked best about writing this book, though, was that I was able to do the three things I love most to do—painting, teaching and talking.

I've painted all of my adult life; I really don't know anything else. I'm not original with this thought, you know, since every colleague of mine has made the same claim.

As for teaching...oh, how satisfying! How very rewarding! You have seen in the various photos of me and my students the fun and good times that we enjoy at our painting sessions. We also learn quite a lot, too.

And what about this matter of talking? I can assure you that I spoke aloud every word before I wrote it. My dear wife, Georgie, represented all of you as I targeted my remarks at her.

In the final analysis, however, the important factor is your role in our learning experience. I patterned this study of dynamic watercolor painting for your interest, for your education, for your study, all focused on making you paint better. I hope you enjoyed reading my text and working with the reproductions of my paintings. If you can come away from this experience knowing one thing you hadn't known before, then this venture truly was a success.

list of paintings

index